IMAGES
of England

NORMANTON

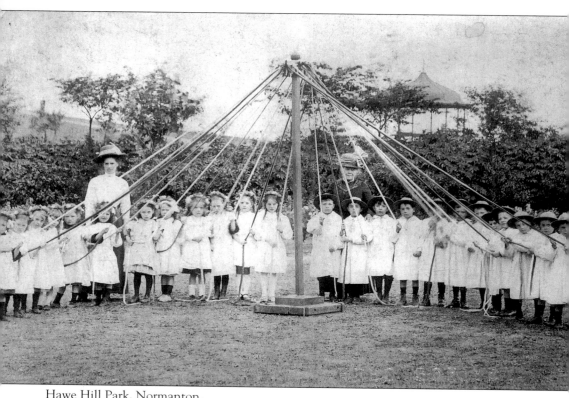

Hawe Hill Park, Normanton.

IMAGES
of England

NORMANTON

Compiled by
Bryan Fraser

TEMPUS

Tempus Publishing Limited
The Mill, Brimscombe Port,
Stroud, Gloucestershire, GL5 2QG

ISBN 0 7524 1503 4

Typesetting and origination by
Tempus Publishing Limited
Printed in Great Britain by
Midway Clark Printing, Wiltshire

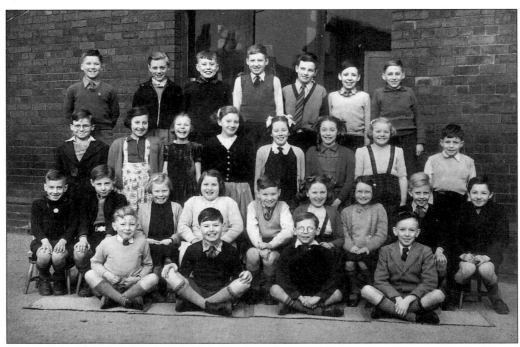

Normanton Church School, 1952.

4

Contents

Acknowledgements

This book would not be possible without the help of the people of Normanton who over the years have given me their time, photographs and memories. I would like to thank in particular the local members of the RSVP (Retired Senior Volunteer Programme). RSVP is part of the Community Service Volunteers and provides opportunities for volunteers over fifty who want to become involved in the local community. They helped me to establish an oral history society, which ensures local history and dialect is recorded for future generations. The society consists of myself as secretary, Reverend Ron Ayres as chairman, Betty Armitage, Kathleen Baxter, David Armitage, Marie Thompson and Shirley Schofield. We are always looking for new members.

Old Photographs Wanted!

I once visited a lady to see her collection of photographs. As I arrived I noticed she had been throwing some photographs on the fire. 'What do you want them for?' she asked as I removed them from the fire, 'they are of no interest to anyone.' Today I have proved her wrong. Hundreds of similar photographs are thrown away every year, they have no financial value but they are a valuable part of Normanton's historical records, as are old invoices and other paperwork. If you do not want your family photographs please send them to me. Maybe in years to come your family will want to see their forebears and discover more about the life they led. Alternatively I am always willing to copy photographs if you do not wish to part with them.

B. Fraser
54 Illingwoth Avenue
Altofts
Normanton
West Yorkshire

Introduction

The coming of the railways in 1840 brought a boom to Normanton. The good quality coal mined from beneath the town could now be transported all over the world. Men and boys were needed to operate the trains, man the station and to work in the mines and other businesses that took advantage of the expanding industrial opportunities in Normanton. Among these were the brickworks to enable houses to be built, shops to provide food, horses and stables for transport and joinery shops to manufacture furniture. The women worked long hours to feed and clothe their families. Elder daughters travelled to the nearby cities to work in the homes of the rich or worked twelve hour days in local shops and businesses, while the younger children helped in the home. It is these people and their families who constitute the history of Normanton, rather than the inanimate buildings and streets.

The rapid expansion from a population of approximately 750, in the then two villages of Normanton and Altofts, to 17,000 in the space of thirty years, created many social and medical problems. The local boards struggled with the problems of providing drinking water, sewerage facilities, policing, basic medical care, paved and lighted walkways and roads, schools, parks, libraries and recreation areas. The religious and social needs were met by a variety of groups and societies. These groups raised money for hospitals, churches, chapels, schools and midwives as well as rallying support when emergencies arose. Often the support of these organisations was necessitated by the constant struggle to improve pay and conditions for the 10,000 miners who worked in the collieries within a two mile radius of the town centre.

In addition the entertainment they provided allowed people a small break from the unremitting needs of work, dust and grime. In their hundreds or thousands crowds watched or took part in local shows, galas and sports. Weddings were always festive occasions. At the wedding between the daughter of the landlord of the Station Hotel and the son of the landlord at the Junction Hotel, hundreds of guests celebrated in the Market Place for two days and nights. Many of these groups and societies disbanded with the introduction of the Health Service and Social Security.

During the 150 years since the advent of the railway, local people have distinguished themselves in many ways. A man from Normanton was part of the team that pioneered the jet engine, another designed the majority of the world's most renowned golf courses, including Augusta where the US Masters is held. Many brought great praise to the town for their bravery in two World Wars. Others have demonstrated, and continue to do so, their skills in the field of sport. People from the town have represented county and country in their chosen sports and others have played professional football and rugby – the list goes on. So let us have a glimpse of the people who made that history.

Bryan Fraser
1998

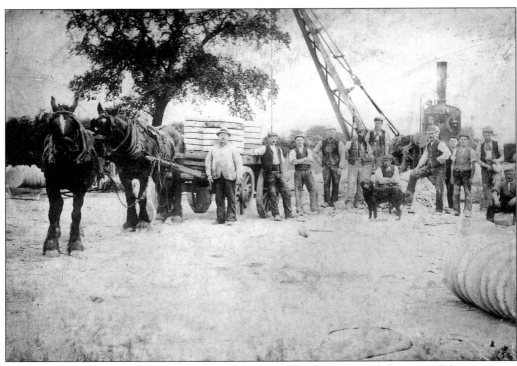

Workmen at Snydale Quarry pose in front of the steam crane, around the turn of the century.

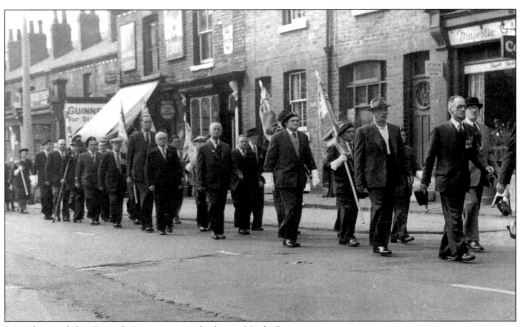

Members of the British Legion march down High Street.

One
Industry and Workers

The arrival of the railway in 1840 made viable the mining of coal around and under Normanton. Other industries followed.

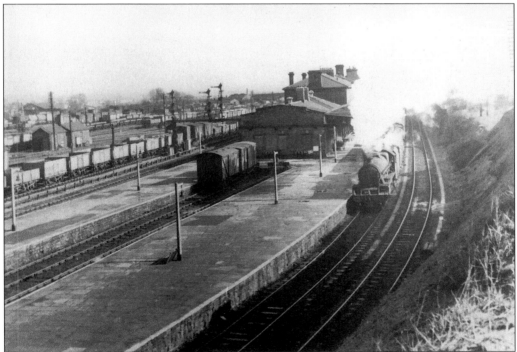

For over one hundred years Normanton Station bustled with trains and people. However, the activity of the station declined and now only a fraction of one of the original platforms is left.

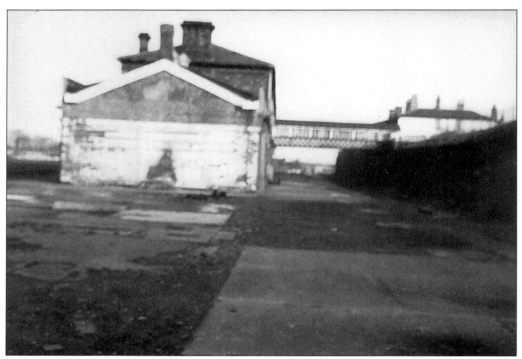

Normanton Station towards its demise.

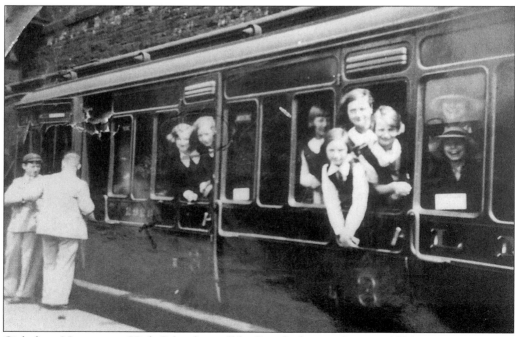

Girls from Normanton High School set off for Stratford-upon-Avon in 1934.

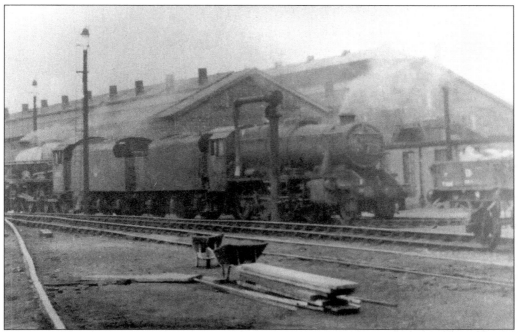

Normanton locomotive sheds in 1930. These were used for the service and repair of the many hundreds of steam trains that operated around the station. Sadly they have all now disappeared.

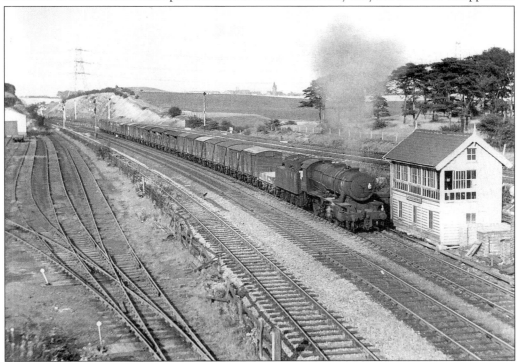

A steam train passes the Goosehill Junction and the St Johns Colliery sidings. Neither of these remain today.

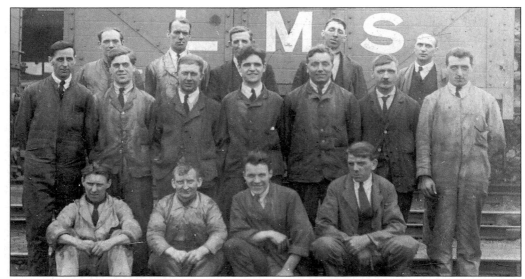

The maintenance men, back row, from left to right: C. Brown, F. Head, ? Dodsworth, E.H. Williams, T. Howell. Second row: A. Doody, J. Hampson, J. Douglas, G. Grice, -?-, H. Stokes, A. Moody. Front row: -?-, -?-, H. Stokes, W. Hampson.

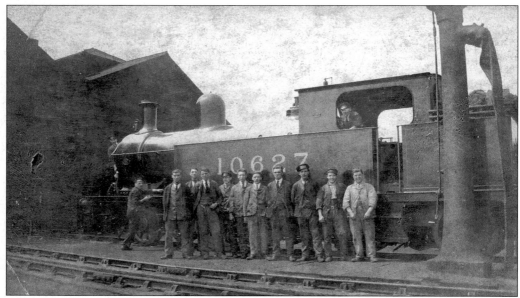

Normanton sheds. In the cab is A. Moody. Pictured from left to right are: H. Brown, P. Doody, F. Head, J. Hampson, R. Dodsworth, J. Douglas, L. Turnbull, G. Grice, H. Williams, H. Stokes, -?-(driver).

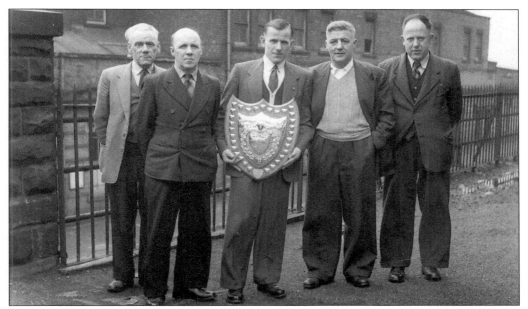

Normanton railwaymen, winners of the Leeds and District Railway Ambulance Shield in 1960. Standing in front of the station, from left to right: S. Hall, H. Stokes, G.W. Wakenshaw, H. Selway (captain), J Rummings.

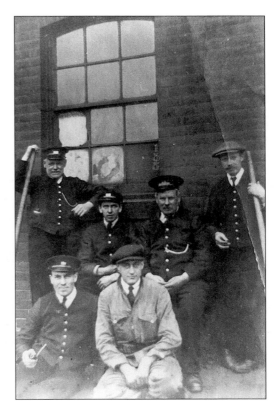

Normanton south yard train shunters in 1940. Among those pictured are: J. Travers, G. Jenkins, ? Baldwin.

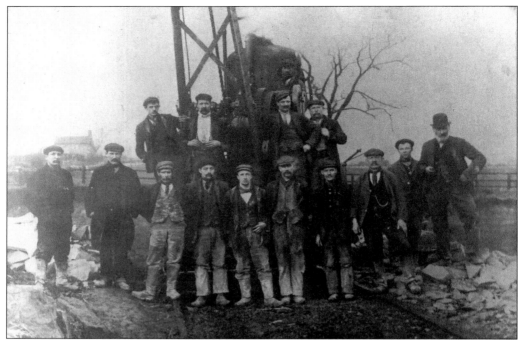

The blue grit stone that was worked in Snydale Quarry had been discovered when a mine shaft was sunk. The man on the steam crane is R. Hall (a Shide maker). Of the four men at the back, ? Gott is on the left and G. Weelan is on the right. At the front, from left to right are: -?- , P. Sykes, B. Rhodes, J. Taylor, -?-, -?-, -?-, -?-, -?-, ? Simpson.

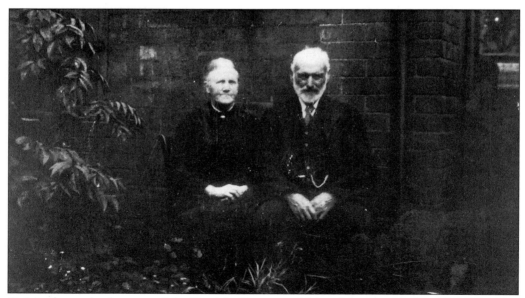

G. Marchant, the foreman of the Snydale Quarry, and his wife are pictured in 1920. The blue grit sharpening stones were exported worldwide.

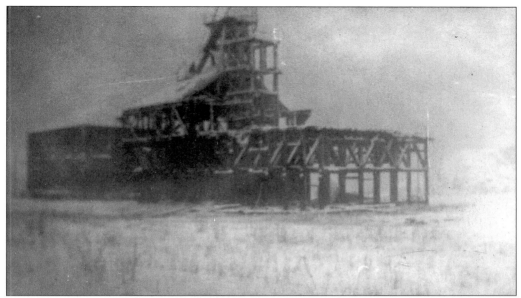

The Don Pedro Colliery, pictured in winter. The colliery was part of the Briggs Mining Company. This was one of the many collieries around Normanton that men and boys would walk to in order to try and obtain employment, many times they would return home unlucky.

Part of the Don Pedro workshops. From left to right they are: a blacksmiths, a joiner and the stable for 'Piper'.

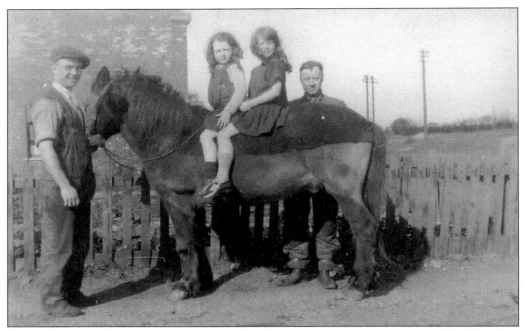

Pictured here are Piper with B. Haigh and W. Womersley on his back, J. Bagnall holding him and Mr Haigh behind.

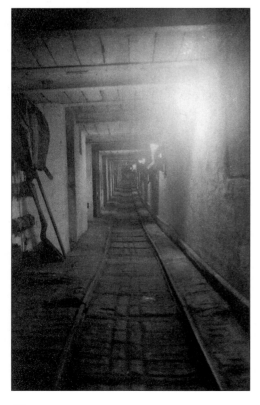

The Don Pedro underground stables.

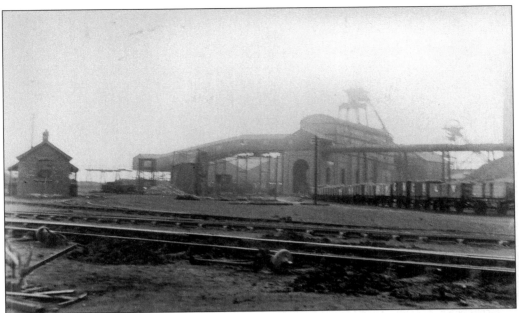

Whitwood Silkstone Colliery, *c.* 1900. This was another of the Briggs collieries. At one stage this company produced more coal than any other company in Europe. However the collieries were outside the town's boundries so they paid no business rates to Normanton.

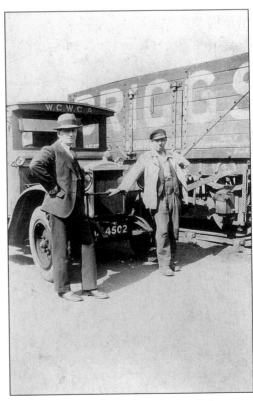

Over 5,000 men worked in the Briggs collieries around Normanton. Here A. Boyes (right) prepares to deliver local coal.

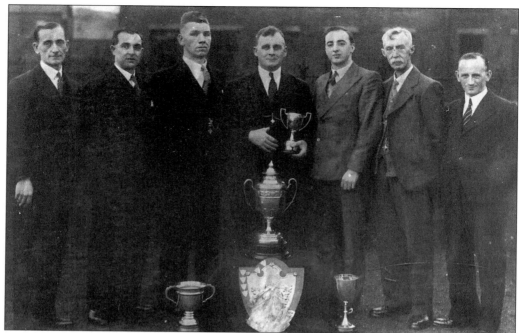

The Pope and Pearson Ltd, West Riding Colliery Ambulance Team. They were winners, in 1936, of the Normanton and District Challenge Cup and other awards. From left to right: J.E. Waring (manager), R. Beecher, J. Potts, A. Long (captain), A. Knowles (under manager), T.A. Cockell, A. Johnson.

Fox Drift Colliery with the baths in the background. The Fox Drift Colliery was situated on the island formed by the Aire and Calder canal and the river at Altofts. Prior to this a pit shaft had been sunk on the Altofts side of the canal.

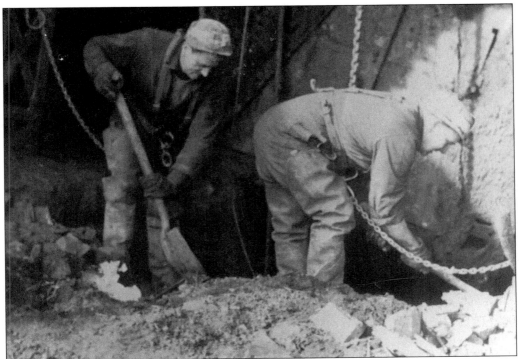

A. Hutchinson and W. Jeffreys are seen filling the shaft at the Fox Drift Colliery in 1968. The Fox was the last of the Normanton area collieries to be sunk.

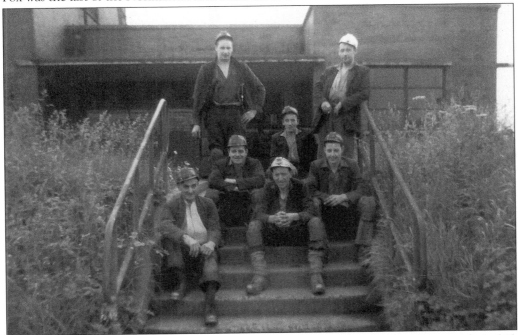

Miners sit on the steps leading to the baths at the Fox Drift Colliery, prior to starting their shift underground. At the front are A. Webster (left) and D. Reynard (right).

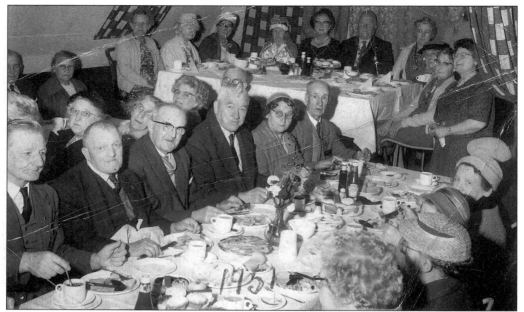

Normanton's Chamber of Trade in 1951. Included here are: B. Stead, J. Banks, B. Watson, J. Stead, Messrs Jackson and Eccles, G. Bennet, B. Gillard, Mrs J. Stead, Mrs and Miss Jackson, E. Shear, Mr Dolpin, Mrs Limb, Mrs Walker, Mrs Lacy, Miss D. Banks, Mrs Hopton, Mr Dolpin, Mrs Feldon, Mrs Westwood, Mrs Carey, Mr Lacy, Mrs Hopton, Mr and Mrs Webster.

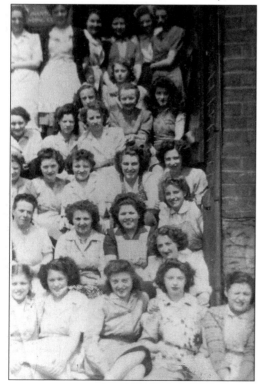

Workers at the old Velvet Mill in 1949. The mill was located opposite to the Roman Catholic church. Included among those pictured are: L. Phelps, E. Green, E. Exley, M. Booth, K. Beecher, B. Green, C. Gill, B. Jubb, D. Cockle, M. Parkinson, V. Raybould, O. Ambler, S. Kitchen, M. Wormstone.

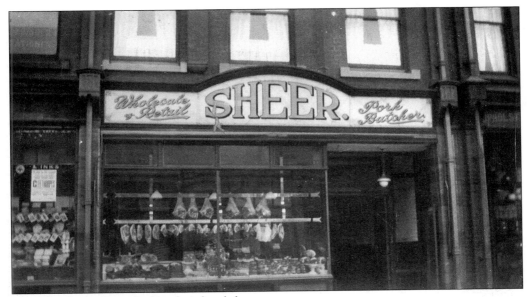

Many local people worked in their local shops.

E. Thompson stands in front of his shop in the 1940s. Behind this, not visible here, was Rowley's blacksmiths. The building behind the shop was the former Salvation Army building, later called the old Velvet Mill.

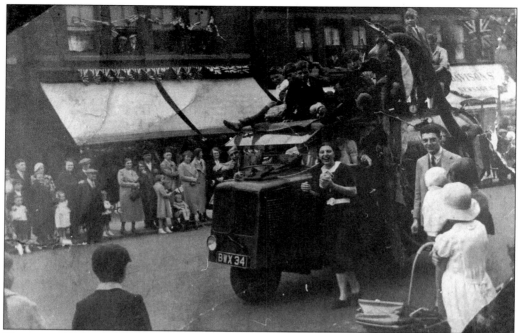

Normanton council shows off their latest purchase – their first gully cleaner – at a gala in the 1930s. The men behind are looking out of the windows of the old Coronation WMC.

One of the unsung heroines of the town is a mother, Mrs Bolton. She lived on Wakefield Road near Market Street and had twenty-one children, of whom only nine survived.

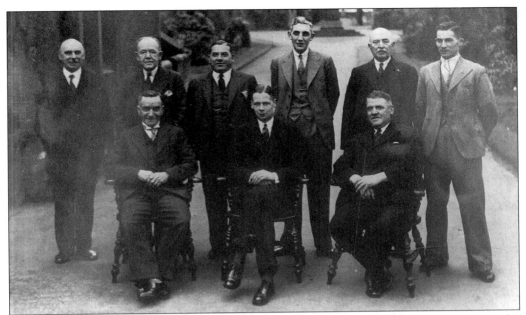

Altofts, prior to its amalgamation with Normanton in 1938, ran its own affairs. In 1937 the town's officials were, back row from left to right: T. Beddows, W. Davies, Councillor E. Walton, A. Hawkins (clerk), Dr H. Schofield (medical officer), T.H. Hailstone (surveyor). Front row: Councillors F. Hampshire, O.H. Jones, T. Hargrave.

Young female workers from the Yorkshire Electric detonator works, in the 1930s. They take a few minutes rest before resuming their work. Pictured are: E. Beaumont, N. Sambrook, M. Flynn, L. Saxton, C. Jones, N. Patchett, A. Hartley, D. Hurley.

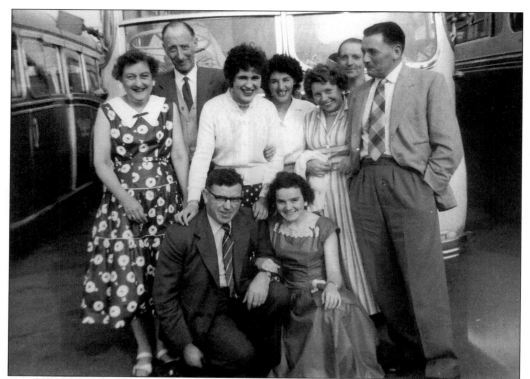

Works and club outings were still popular after the war. Very few families had motor cars so a long train or a procession of buses took the families of Normanton for their day trips to the coast. Among those pictured are: D. Bolton, D. Wadeley, E. Spencer, J. Elkes, J. McTear and Mr H. Blackburn (the managing director of the detonator works kneeling at the front).

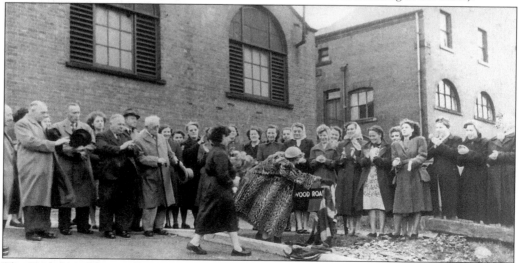

The Yorkshire Electric Detonator Company was established in Normanton in 1912, but in 1972 the company was taken over by ICI. Here the workers celebrate the unveiling of a road sign. When land around the original factory was cleared, after the works were closed, some discarded detonators blew up killing one of the workers.

Two
Religion

The churches and chapels influenced the way in which Normanton people lived. Once money had been raised to build the churches and chapels they in turn helped many local charities.

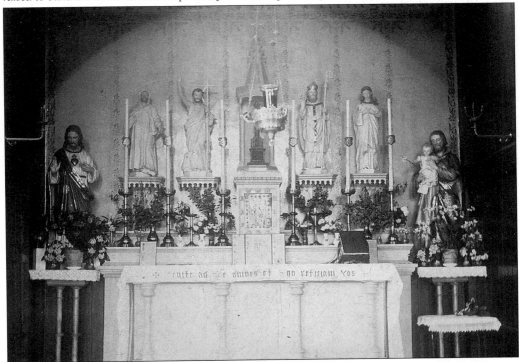

This is the altar of the Roman Catholic Sacred Heart church that used to stand at the bottom of Castleford Road.

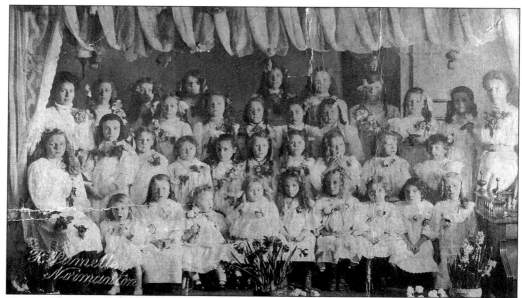

Thousands of the town's children attended the Sunday schools of the various churches and chapels. This is one class at the Altofts Methodist Sunday school in 1910.

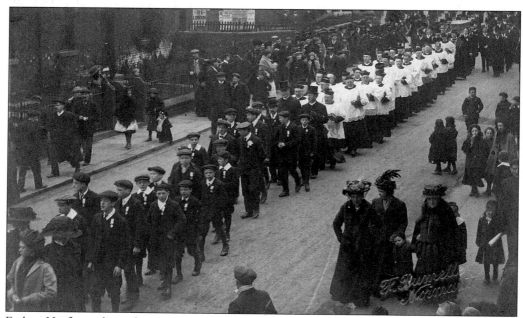

Father Herfkens funeral, in 1911. The man (centre) with top hat and moustache is Benny Brookes who ran an ice cream business for many years.

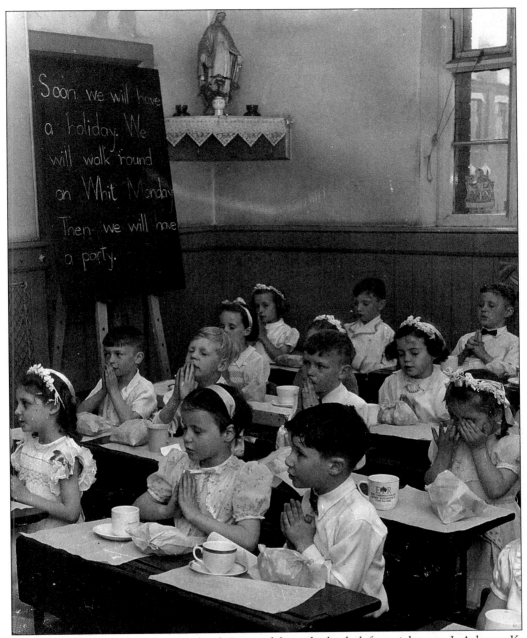

A scene in the Roman Catholic school. Pictured from the back, left to right, are: J. Ashurst, K. Derosey, -?-, J. Morgan. A. Crumack, -?- , M. Smith, E. Harding, J. Filochowski, ? Birchall, M. Connelly, R. McDermot, K. Higgins, A. Lane. Julian Filochowski is now director general of the Catholic fund for overseas development.

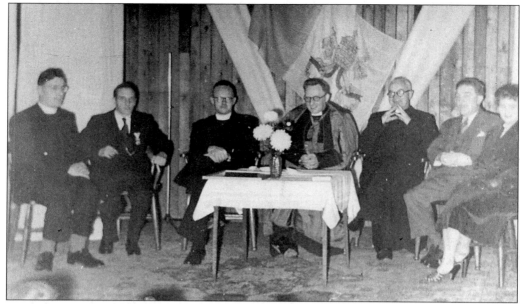

The church and school halls were used for many social functions. Pictured here, from left to right: Monseigneur Sullivan, Mr E. Woolaghan, Monseigneur Thompson, Father O'Hara, Father O'Connel, Mr E. Westwood, Mrs S. Reeves. They were holding a meeting in the Roman Catholic hall.

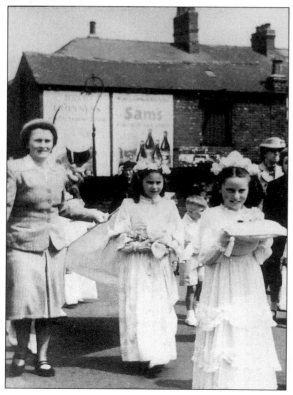

Mrs Hughes helps her daughter to prepare for one of the many Roman Catholic church parades which processed through the town.

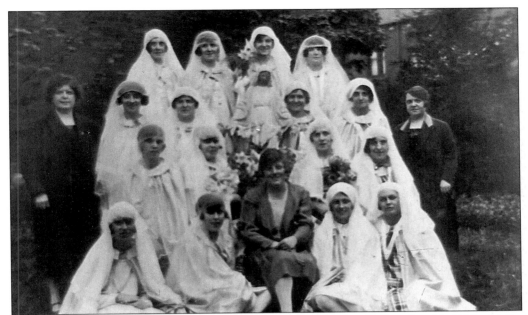

Children of Mary, 1918. Those pictured include: Mrs McCauley, T. Brookes, M. O'Hara, Miss Walker, K. Fisher, N. Brookes, W. Melvin, L. Kaiser, M. Byford, C. Crashly, M. Cunnif, M. Fratley, M. Duchene, A. McNaney, E. Follis, W. Smith.

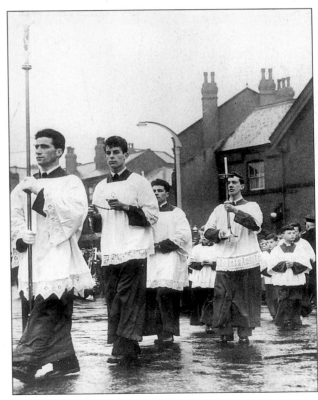

T. Holley, followed by D. Hartill, D. Holley and L. Purdy lead the parade into Market Place.

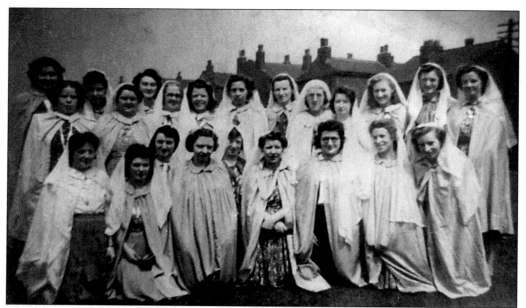

Children of Mary, 1958. Back row from left to right: -?-, C. Hutchinson, K. McDermott, Pickering, Brookes, -?-, -?-, Brookes, -?-, -?-, -?-, -?-, -?-, W. McGuire. Front row: -?-, -?-, McDermott, S. Blakeston, A. Kaney, Reynolds, Hall, Feeley, S. Myres.

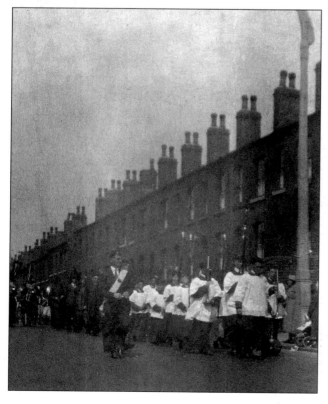

The Roman Catholic choir leads the procession along Wakefield Road.

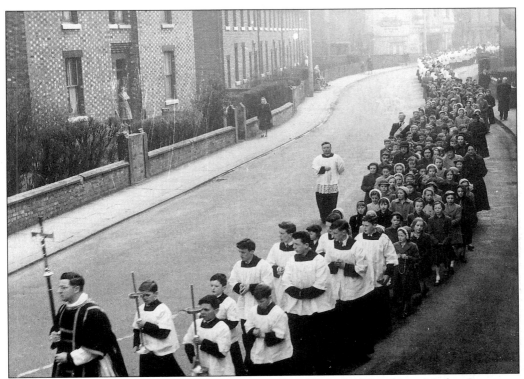

Here a Roman Catholic procession begins to turn from Wakefield Road into Market Street.

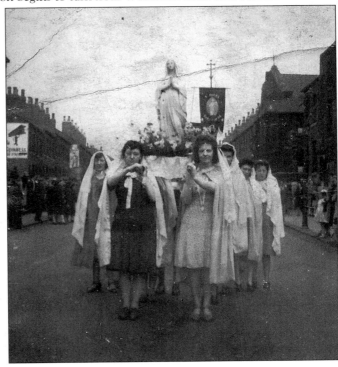

Another procession passes the Methodist church. Among those pictured are: Mrs Scott, Ms McNulty, Ms Edmunson, A. Kaney, ? Kimberley, D. Kimberley.

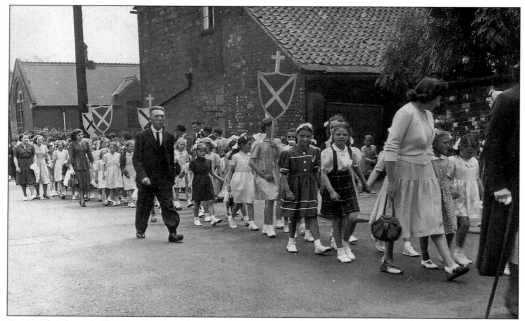

A parish church Easter procession parades past the church school towards Normanton town centre. Bill Bellwood can be seen to the left of centre.

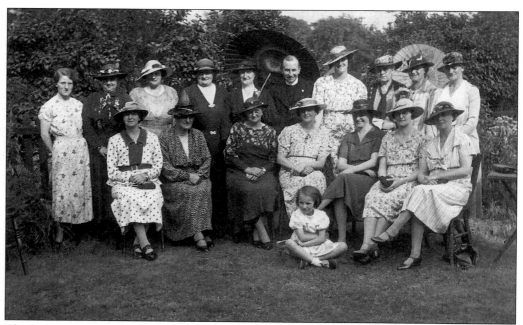

The ladies of Normanton parish church meet in the 1920s. Those pictured include: D. Butler, Mrs Burton, Cannon Orgill, Mrs Randall, Mrs Dennison, Mrs Soles, Miss Butler, Miss Cockill, Mrs J. Dennison, M. Robinson, D. Scar, N. Darwell.

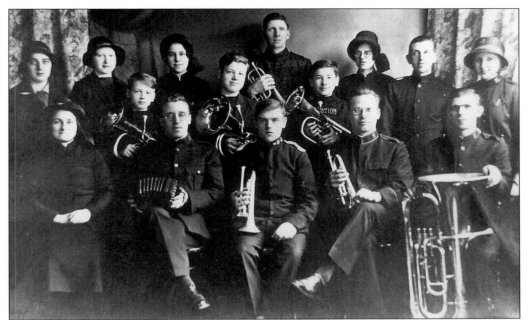

Salvation Army Band, 1932. Pictured with their instruments, back row from left to right: F. Appleyard, L. Hensby, B. Greenwood, F. Garside, L. Thompson, F. Smith, L. Hardwick. Middle row: L. Hensby, A. Hensby, F. Law. Front row: Miss Copeland, Captain Fisher, Lieutenant E. Hensby, ? Goldsack, J. Dawson

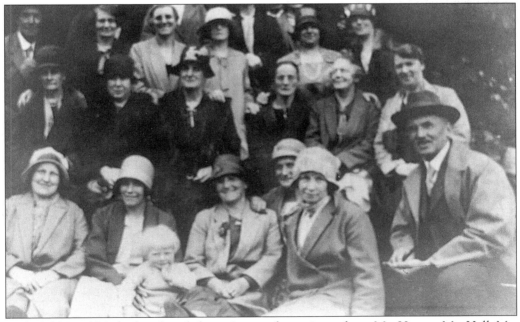

Wakefield Road Methodist chapel choir. Among those pictured are: Mrs Harper, Mrs Hall, Mrs Hughes, Mrs Guy, Mrs Knowles, Mrs Shearn, Mrs Borrill, Mrs Prentice, M. Skidmore, M. Knowles, J. Dixon, E. Hall, J. Prentice.

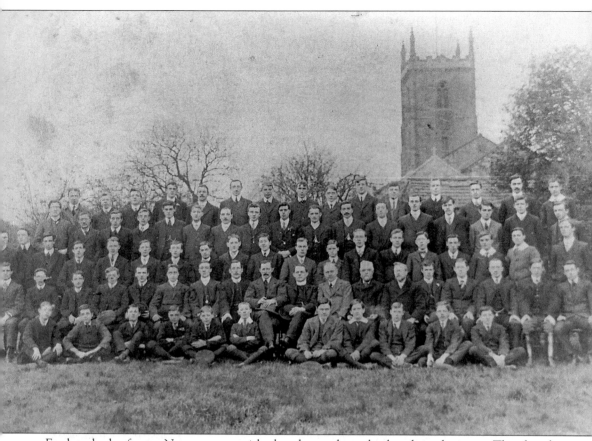

For hundreds of years Normanton parish church was the only church in the town. The church owned land locally and as the population grew church-owned land was sold to raise funds to build the first junior school, which now accommodates the church rooms. More land was sold to build the present Church School. The many members of the Church Institute (pictured) manage the finances.

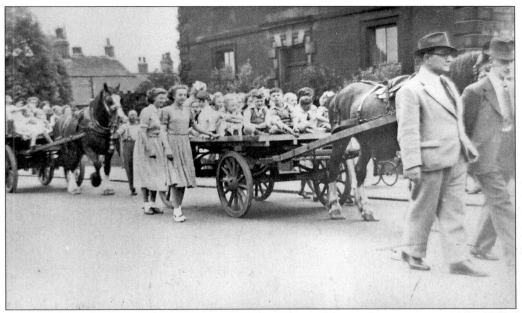

Older children look after the younger ones who ride in this parish procession in the 1950s. Second on the right is Stan Tomlinson who was the headmaster of Woodhouse junior school for many years.

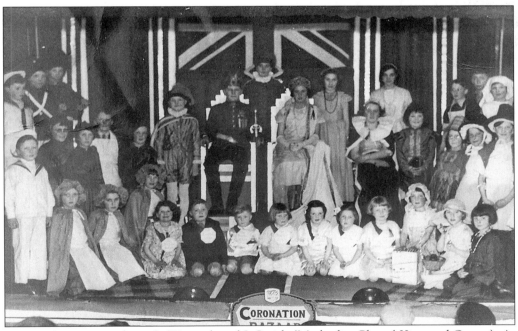

Among those pictured are: L. Womack and J. Smith (Methodist Chapel King and Queen), A. Hall, M. Kirk, M. Dunbar, A. Kirk, J. Prentice, P. Addy, M. Knowles, B. Churchill, E. Hall, L. Churchill, R. Durbin, D. Durbin, K. Wandess, D. Partridge, W. Cookson, D. Skidmore, I. Limb, P. Holt, G. Skidmore, M. Whittingham, M. Holmes, B. Limb, W. Hall, M. Lythe.

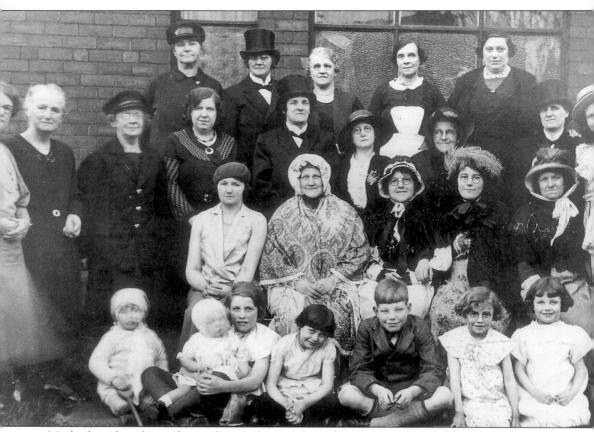

Methodist chapel members rehearse for a show. Those pictured include: Mrs Swaine, Mrs Womack, M. Hall, Revd Lacey, Mr Wormack, P. Holt, W. Smith, J. Moss, W. Hall, A. Goodlad, J. Kiddle, C. Morley, J. Swaine, E. Dickinson, M. Kirk, E. Skidmore, D. Martin.

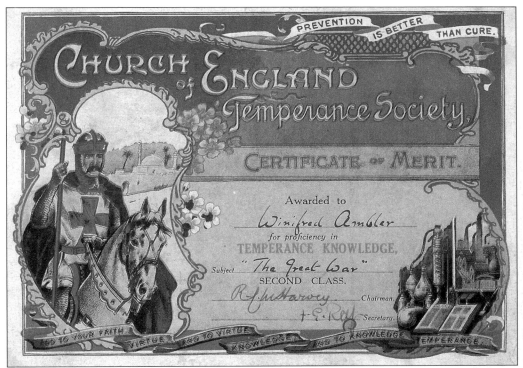

The Temperance Movement was very strong over a period of fifty years to the 1880s. Many, like Winifred, signed the pledge. During this time parents would often take their children and hold demonstrations outside public houses.

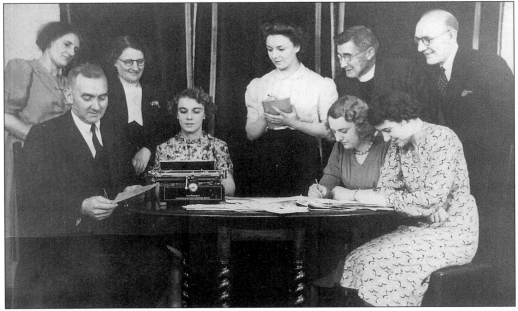

At the Methodist chapel a group gather and type up local news to send to Normanton people serving in the forces during the Second World War.

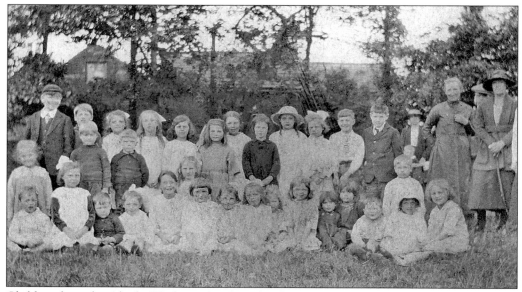

Children from the Altofts Wesleyan Sunday school in 1908.

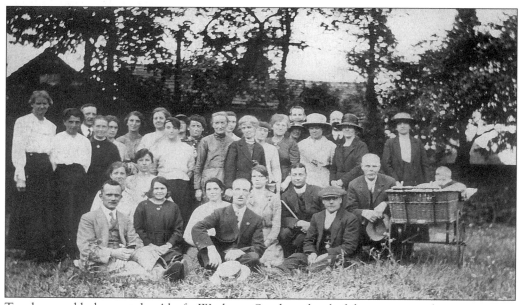

Teachers and helpers at the Altofts Wesleyan Sunday school of the same period.

Three
Transport

Local transport was, for many years, by horse or on foot but the boom changed all that. When the Normanton area collieries were working five days per week families could afford to have a day out.

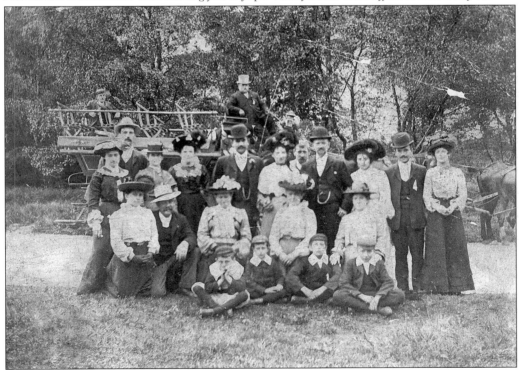

Among the passengers on this Normanton wagonette were the Steven's family.

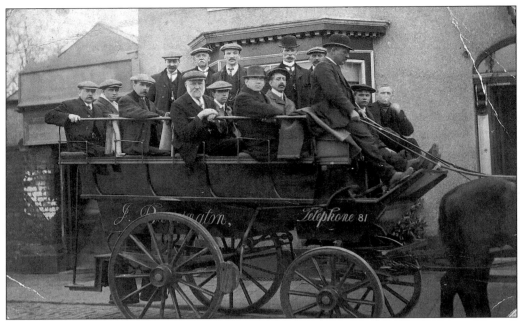

By the end of the last century regular wagonette services were available in the town. This all male outing includes Mr Hepworth (centre, with a beard).

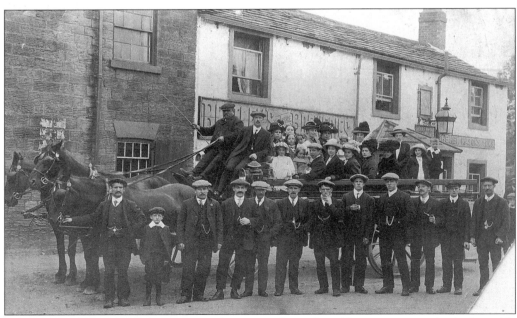

Mr Joe 'Hough' Jackson's wagonette and a group of men from Normanton are pictured outside The Mason's Arms, Woodlesford, in the 1920s. Mr Jackson kept stables on Benson Lane.

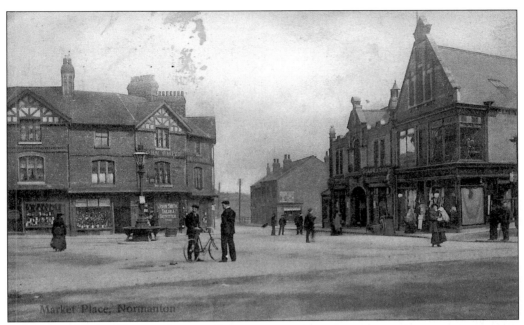

Normanton Market Place at the turn of the century.

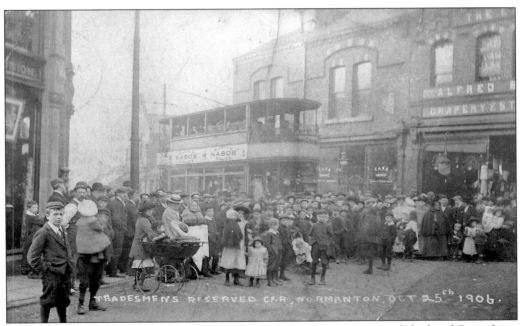

In 1906 a tram service was started which connected Normanton to Castleford and Pontefract. This tram, on the first day of the new service, waits to start its journey from High Street.

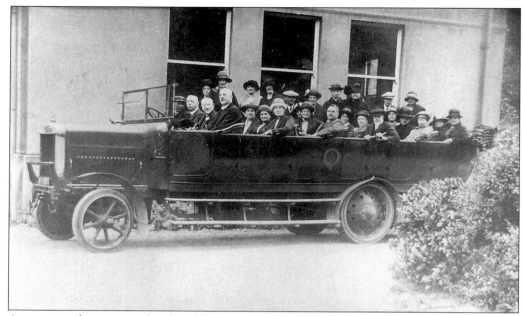

As motorized transport developed coach companies began to challenge the railways. This Normanton outing with Ben Taylor, a local grocer (front seat), was on a 'Karrier' named King George. It had three different frames, one for a flat-bed lorry, one for passengers and the other for use as a furniture van.

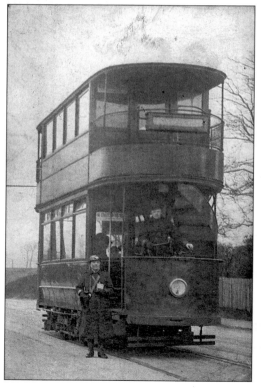

As the bus companies increased their services the trams struggled for passengers. Here Joe Birch stands in front of his tram near Normanton park, waiting for passengers.

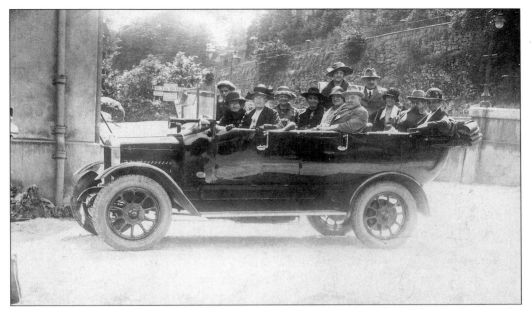

Families would club together to hire transport for a day out. The Lily family stand up on the charabanc to pose for this photograph.

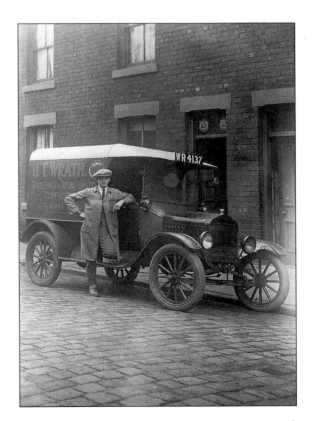

Small vans became a common sight, along with the horses and carts, as traders made use of this new method of transport to visit the housewives of Normanton and sell their wares.

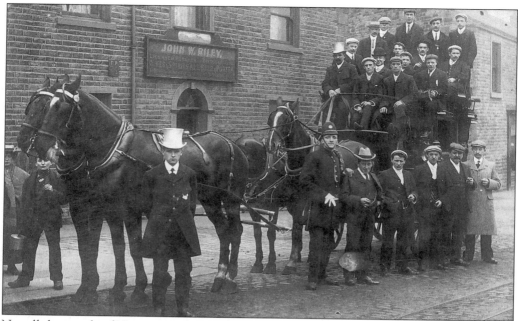

Not all the people of Normanton favoured motorised transport. It was noisy and prone to break down, so horse-drawn transport was still used for many years. Some Normanton men are pictured here on their way to a local racecourse.

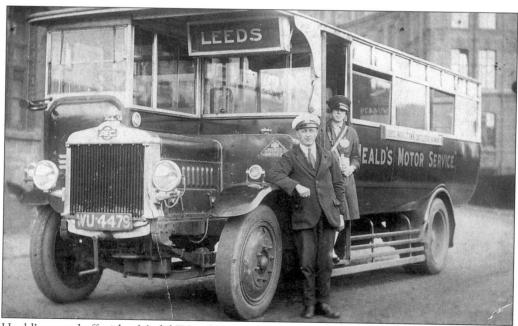

Heald's started off with a Model T Ford, then ran charabancs from a garage in March Street just off Wakefield Road, Normanton. Trips to Boston Spa, Wetherby and Knaresborough were all popular days out.

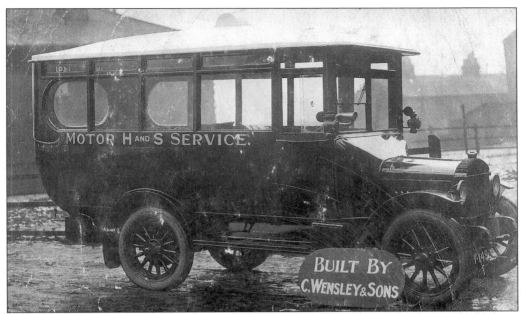

After the First World War Heald's purchased two Steward buses and named them Sunbeam and Primrose. With these vehicles they ran services to the coast until 1927 when Bullock & Sons purchased the business.

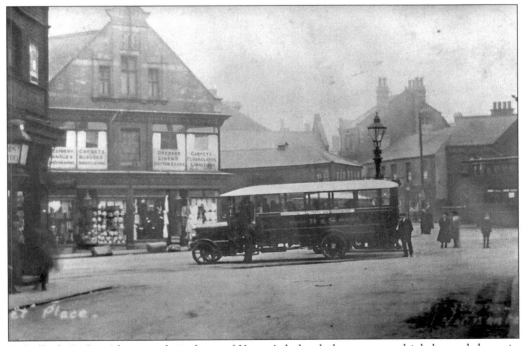

A Bullock & Sons' bus stands in front of Young's haberdashery store, which burned down in 1938. Note the tram on the right. The tram companies tried to compete with the new bus service, but eventually gave up the struggle. The last tram ran in Normanton in 1925.

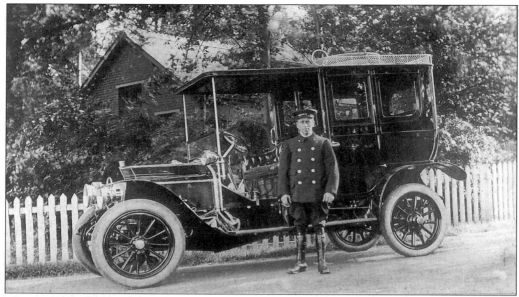

The richer local families could afford their own transport. William Garforth (later to become Sir William Garforth), managing director of the West Riding Colliery at Altofts, arranged in 1910 for Raymond Lilley to be trained by the Wolsey Company and then employed him as his chauffeur.

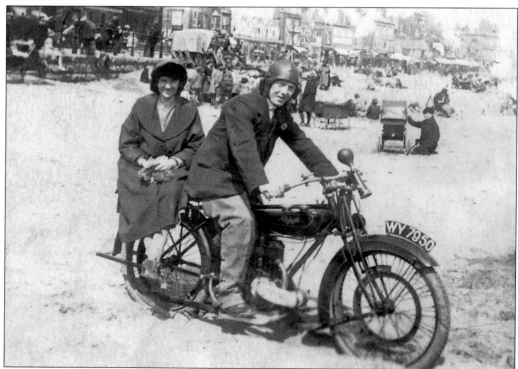

Not so wealthy; Hughie Burns and Cissie Allbright enjoy an outing to Scarborough in the 1920s.

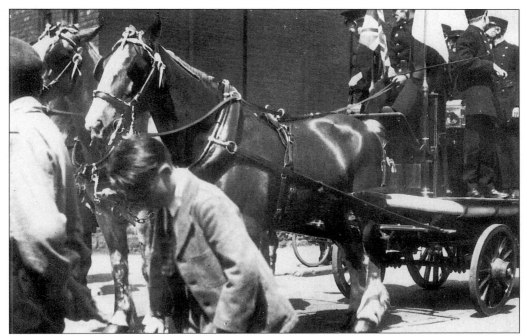

In 1897 a cart was provided for Normanton's volunteer fire brigade to carry the ladders and buckets.

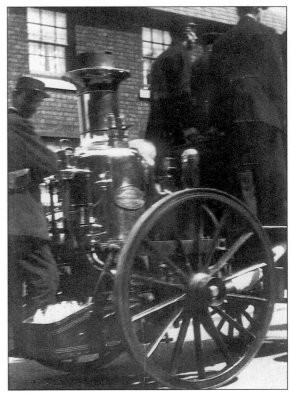

Horses were still needed to pull both the engine and the cart transporting the ladders. In the early 1900s a steam-driven fire engine was purchased.

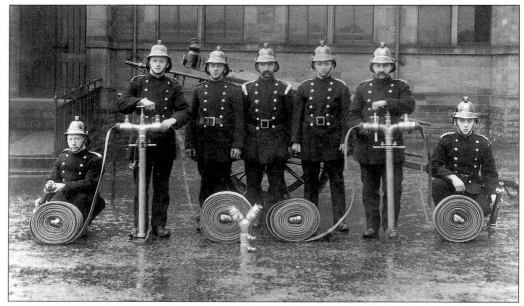

Normanton's fire brigade pre-First World War. In September 1897 the fire brigade members were provided with helmets and belts. They also had iron plates to display outside their homes to inform the public where they could be contacted.

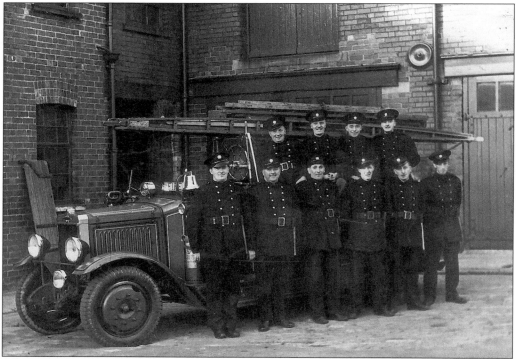

Normanton's fire brigade in 1947. They stand in front of the fire station in the old council yard. Back row, from left to right: H. Chapman, W.F. Holt, F. Barraclough, -?-. Front row: J. Holt, F. Picket, J. Evans, T. Turner, W. Fawkinham, R. Sparks.

Four

Schools

Normanton Grammar School on Snydale Road (opposite the church) was, for approximately 250 years, Normanton's only school. With the advent of the railway the population expanded rapidly. The first new school to be built was the National (Church) School in 1850. It was extended in 1867 and rebuilt in 1898. By this time other schools had been established to educate the increasing number of children.

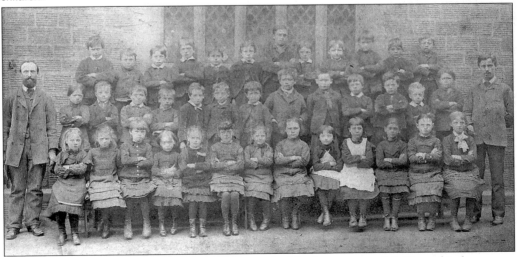

Normanton National (Church) School at the end of the last century. Mr Cumerbirch was one of the teachers.

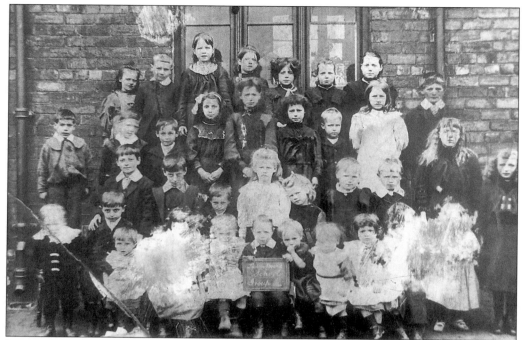

Loscoe School, 1886. Many of the children from the nearby Briggs Colliery Company houses atHopetown and Loscoe were sent here.

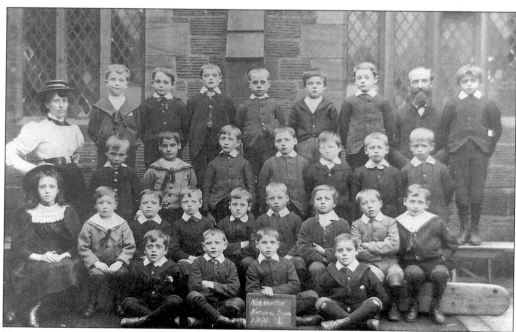

Normanton National (Church) School, 1896.

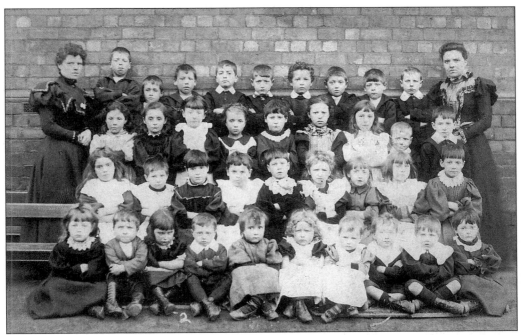

Woodhouse School, possibly in the 1880s. The children of the miners who worked at Sharlston and St Johns Newland Collieries went to this school and the nearby Dodsworth School.

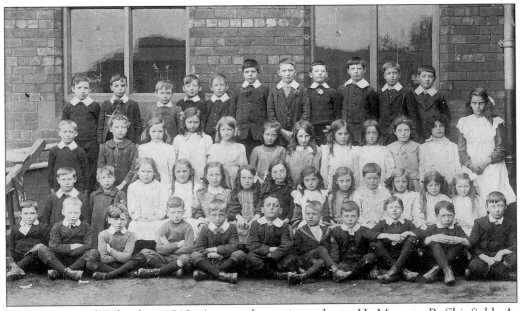

Altofts National School in 1910. Among those pictured are: H. Morgan, P. Shinfield, A. Rawdin, White, Forkinham, M. Marshall, C. Whittle, Albright, M. Coulthard, E. Wild, L. Corbett, L. Shenton, L. Venart, Newsam, L. Walters, A. Bocock, F. Towell.

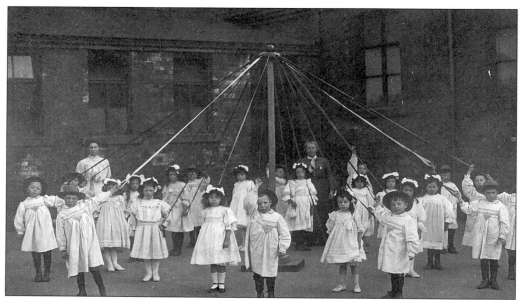

A Normanton Common School class demonstrates Maypole dancing in 1910. One of the three boys at the front is S. Tomlinson, he later became headmaster at Woodhouse School where he worked for many years.

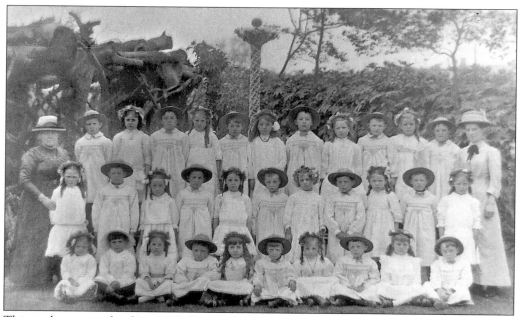

This is the same school in 1912. Pictured are teachers Miss Parr (left) and Miss Tomlinson (right). On the bottom row (fourth from the right) is M. White.

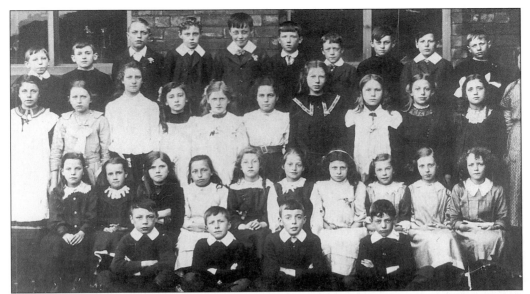

Altofts National School in 1912. The boys on the back row, from left to right are: Lofthouse, Cox,.-?-, -?-, -?-, -?-, -?-, Hanby, Kellet, Bednall. The girls are: F. Wood, F. Ball, M. Wilde, Ball, M. Holmes, C. Blanchard, Gregory, -?-, -?-, L. Black. Front row girls are: F. Threadgold, E. Bains, -?-, C. Fletcher, L. Morgan, L. Thatcher, Forester, N. Rawdin, L. Hancock, K. Hanby. Of the boys on the front row, W. Tolson is on the extreme right.

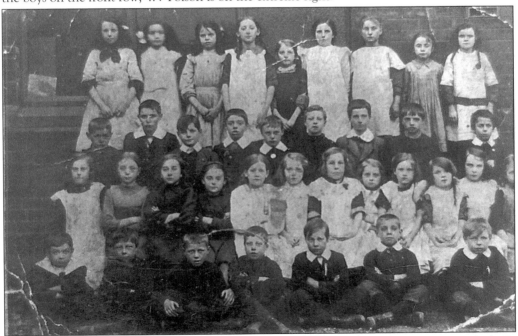

Normanton Church School in 1915. Among those pictured are: E. Axup, Speak, G. Smith, B. Lee, G. Ayland, M. Shaw, K. Dyas, D. Cockell, A. Hudson, J. Pinder, D. Fairhurst, Waddington, Mason, Briggs, Gott, M. Pearson, E. Dixon, A. Clark, C. Roper, M. Spencer, E. Mellor, T. Smith, P. Hague, Raby, Lodge, A. Appleby, H. Hall, D. Hancock, T. Jeffrey.

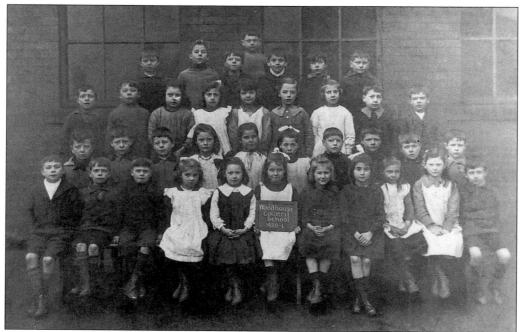

Woodhouse School, 1920-21. At the back (centre) is W. Morse. Third Row, fourth from left is Huskins and on the extreme right is Short. Second row, on the extreme left is J Halliard, W. Farrer is fourth from the right and J. Abbott is on the extreme right. Among those on the front row are: W. Cardwell, J. Brighton, A. Jones.

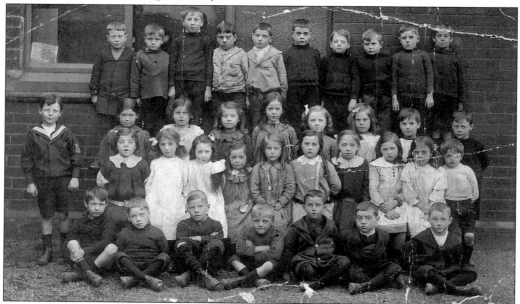

Church School in 1918. Among those pictured are: C. Paver, P. Hill, E. Lee, J. Lunt, Simmons, D. Strout, E. Dancer, N. Carter, M. Roper, S. Reynolds, H. Weldon, B. Sanders, J. Blakeway, H. Armitage, S. Reynards, G.S. Kiven, P. Jones, G. Ward, W. Shingles, M. Lawrence, G. Armitage, L. Briggs.

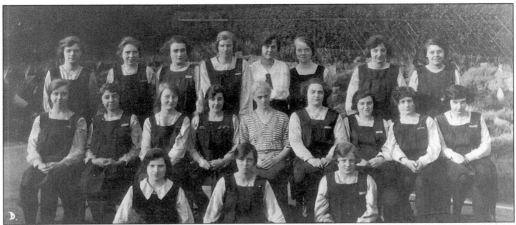

Normanton Girls High School, 1924. Back row, from left to right: E. McKintyre, L. Tomlin, K. Brain, E. Copley, M. Thorpe, E. Dennis, A. Gil, M. Plimer. Among those pictured on the middle row are: E. Farrand, M. Newton, Miss Wright, D. Coe, E. Slatter. Front row: I. Oakley, C. Preston, E. Barnet.

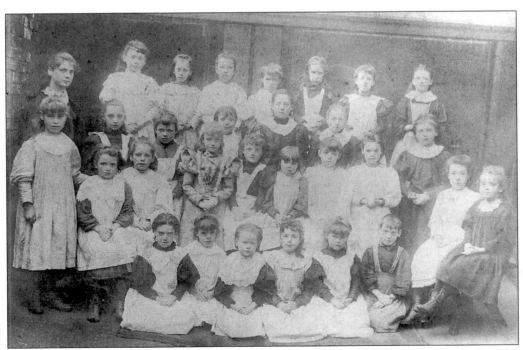

An unknown school class. Back row, from left to right: -?- (teacher), T. Ellis, H. Thorton, H. Errrington, J. Carr, T. Jarret, F. Booth, J. Holland, Standing in front of teacher is A. Lilley. Among those pictured on the front row are ? Ellis, E. Marchant and L. Farren.

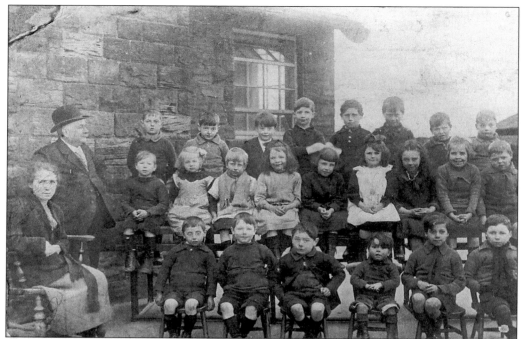

Warmfield in 1924. Pictured are Mr Elliot (headmaster) and Miss Wilby. Among the children pictured are: A. Greasey, A. Milne, C.R. Greasey, I. Greasey, E. Ambler, W. Lambert, A. Greasey.

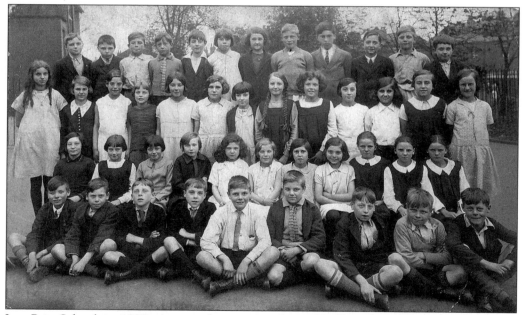

Lee Brig School in 1929. Among those pictured are: T. Sheard, S. Thewsey, C. Reeves, L. Baker, ? Paton, J. Toddington, D. Wakefield, M. Pool, ? Leatham, W. Salmon, ? Simmons, ? Green, ? Smith, ? Davies, J. Brown, J. Petit, ? Morley, ? Brook, L. Kirlow, ? Bedford, D. Wood, ? Cable, ? Cable, ? Cable, A. Hanby, E. Betts, G. Driver, A. Driver, K. Smith, ? Barstow.

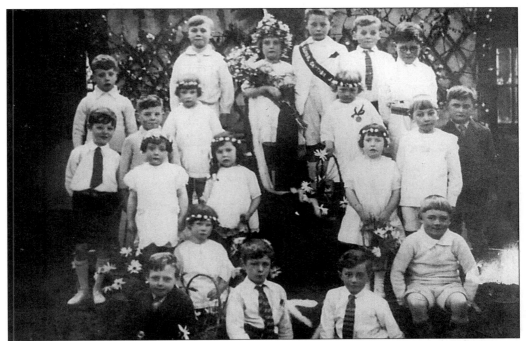

Normanton Common School in 1929. Among those pictured are: R. Bennet, N. Adams, A. Parkinson, A. Spencer, H. Frost, J. Mason, A. Priest, A. Gibson, J. Parkes, E. Bannet, H. Jackson, G. White, B. Illingworth, H. Cole.

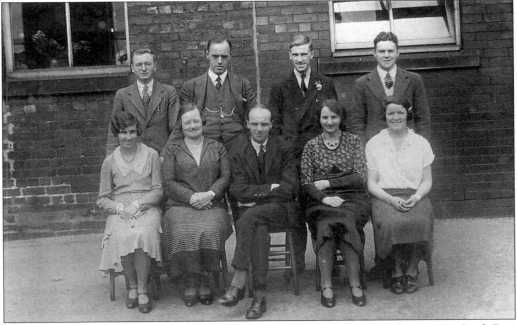

Woodhouse School teachers, 1930. Back row, from left to right: Cliff Roberts, Bert Gard, Bert Hardwick, Fred Elliot. Front row: Florrie Blackburn, Miss Haswell, Ike Sanders, Edna Craven, Elsie Salsbury.

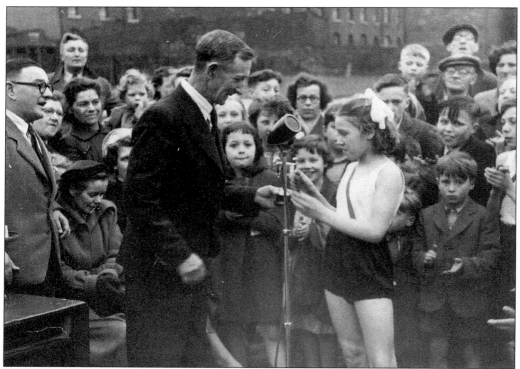

Presentation of Woodhouse School Athletic Trophy to Hedy Webster at Newland Lane End, now the site of a doctors surgery. Headmaster Stan Tomlinson is on the left, wearing glasses.

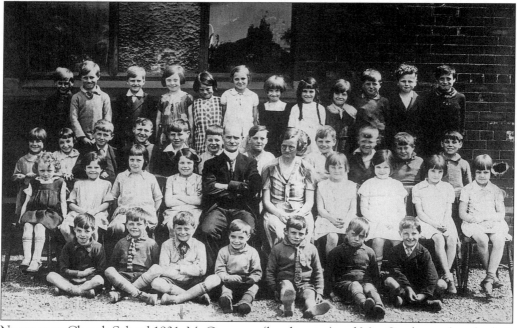

Normanton Church School 1931. Mr Grovenor (headmaster) and Miss Sanderson (teacher) sit in the centre of the group.

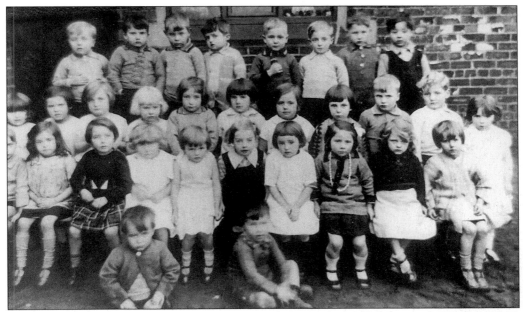

Altofts Church School in 1933. Back row, from left to right: P. Tomlinson, J. Warburton, F. Sharp, C. Smith, D. Hopwood, F. Holgate, M. Smith, B. Hall. Third row: I. Evans, C. Marshall, -?-, B. Bedford, -?-, E. Jollie, J. Taylor, P. Swift, G. Bott, D. Brain, S. Beecher. Second row: T. Sharpe, E. Kellet, M. Stones, Tredgold, M. Blakeway, V. Glen, M. Hodgkins, -?-, M. Maxi. Front row: -?-, G. Briscoe.

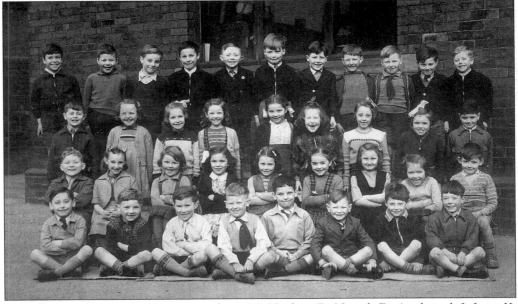

Church School. Among those pictured are: N. Hughes, D. Nuttal, D. Appleyard, J. Law, K. Webster, A. Poole, J. Wilkinson, P. Watson, J. Cooper, J. Williams, K. Massey, V. Rewax, P. Macauley, P. Lythgoe, R. Smith, B. Bentley, J. Simmons, B. Hemmingway, M. Brumby, G. Lyle, G. Sandy, M. Baines, D. Coleman, A. Jones, J. Elsey.

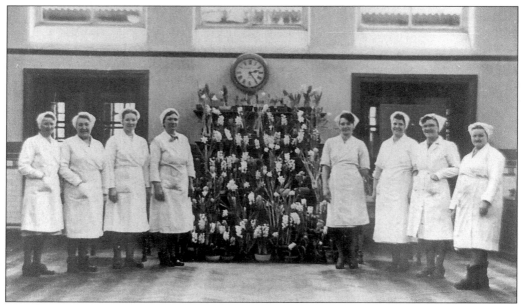

The dinner ladies of Normanton Common School pose in front of the flowers on the school's annual Bulb Day.

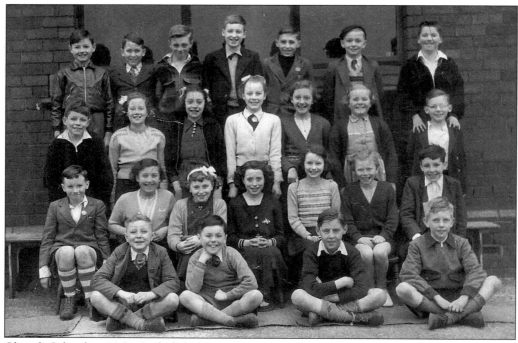

Church School in 1954. Included among those pictured are Appleyard, Marchant (back row), Scott, Norris, Kitchener, Jolliffe (third row), Illingworth, Sanderson, (second row) and R. Allen (front row).

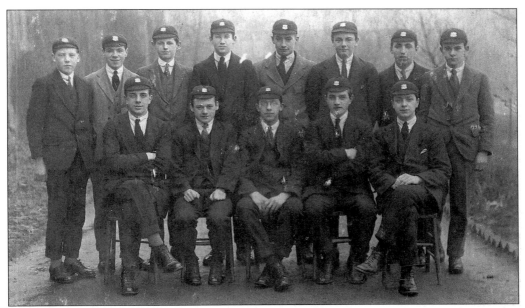

Normanton Grammar School prefects in the 1920s. Back row, from left to right: Hanby, Jackson, Brittain, Croskery, Lailby, Glover, Allen, Denton. Front row: Moore, Swabs, Abbott, J. and F. Mills.

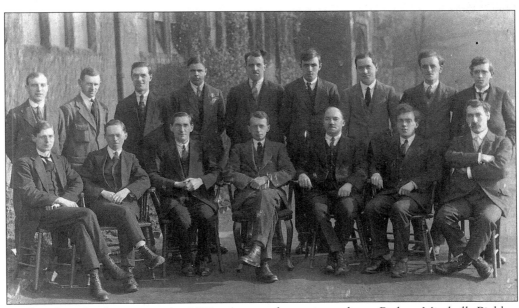

Staff at the school, again in the 1920s. Among those pictured are: Parker, Mitchell, Pickles, Noble, Rainbow, Gott, Merrick, Swallow, Robinson, Brittain, Gimlett, Goldthorpe, Whittlestow.

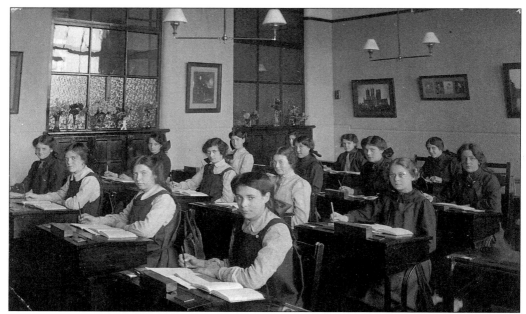

A classroom at the Girls High School. Front row, from left to right: D. Blakeway, F. Cusworth, E. Eaton, E. Spencer. Second row: E. Craven, S. Arnold, D. Mellor, D. Nixon. Third row: E. Hinchcliffe, L. Randale, E. Hudson, D. Wright. Fourth row: Clarice, O. Varley, L. Denton.

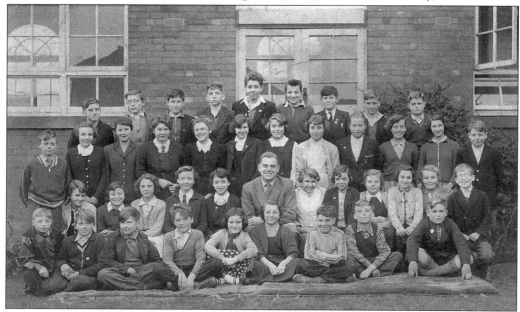

Normanton Secondary Modern in 1956. Among those pictured are: D. Govan, J. Kew, M. Diamond, B. Green, A. Hirst, I. Vaughn, J. Simmonds, M. Parker, A. Garfit, T. Hood, D. Darlow, A. Mathews, J. Golding, J. Wells, M. North, J. Pugh, S. Vause, J. Mace, A. Newton, S. Turner, D. Stead, M. Sweeting, J. Brookes, S. Watson, M. Hurley, L. Kingham, S. Brownson, J. Proctor, V. Firth, B. Jolley, S. Pritchard, A. Barnett, R. Sandy, T. Morris, T. Best, D. Wilson, S. Pearce, P. Collinson, R. Slatter, C. Dyson.

Five

Entertainment

Prior to the opening of the Assembly Rooms in the High Street in 1888, Normanton had little in the way of entertainment. Groups were formed that entertained people and raised money for many local good causes. To a lesser extent this tradition still continues today.

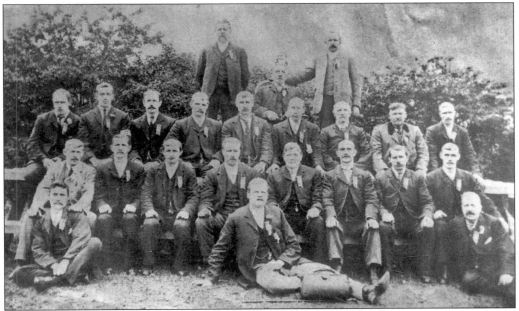

Altofts Hospital Committee arranged many local galas. Among those pictured in 1908 are: Councillor J. Robinson, E. Thompson, W. Davies, F. Thompson Jr, A. Firth, J. Thompson, W. Shelton, R.J. Evans, W. Toddington, J. Atherton, M. Kirby, E. Marsh, J. Garner, W. Hatherton, M. Jones, A. Hoyle, J. Madely, R. Westwood, J. Phillips, J. Minshall, T. Burton.

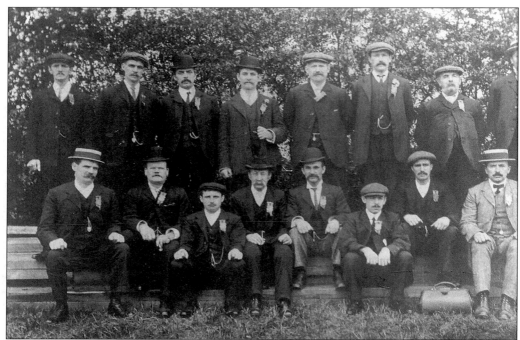

Altofts Hospital Committee at a different date. Back row, from left to right: E. Marsh, B. Westwood, J. Davies, J. Phillips, W. Grieves, J. Thomas, R.J. Evans, T. Robinson. Front row: W. Chilton, J. Minshall, J. Garner, T. Skelton, A. Hoyle, M. Kirby, J.T. Hatherton, W. Davies.

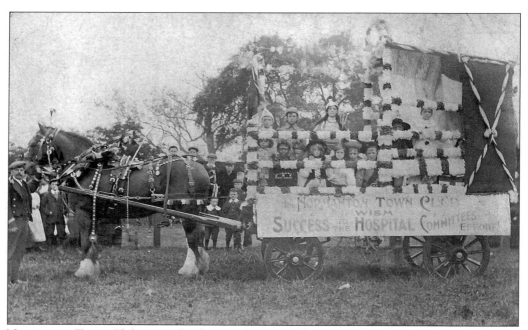

Normanton Town Club entered a float in the carnival organised by the Normanton Hospital Committee.

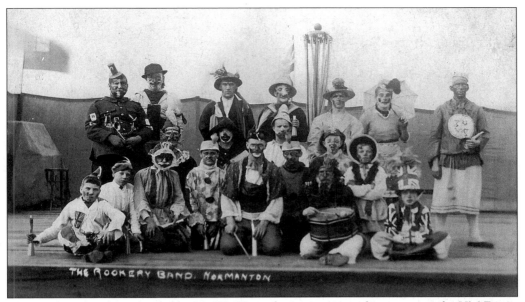

The Rookery Band was formed by Mr W. Wynard to entertain and raise money for HM Forces during the First World War.

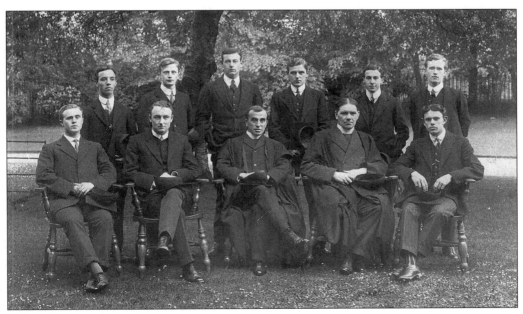

Altofts St Mary choir, 1913.

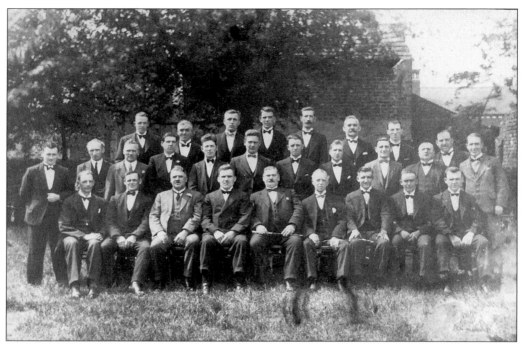

Lee Brig Working Men's Club Male Voice Choir, outside the club in the 1920s.

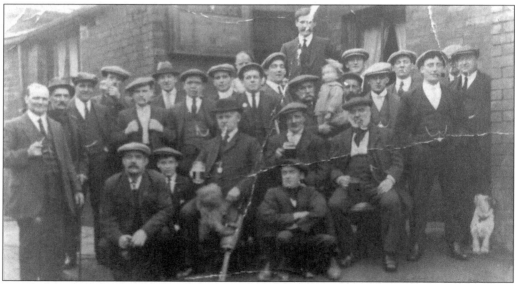

Members of another choir are pictured outside the Robin Hood public house in the 1920s. Included in the picture are: W. Stones, Orwell, Bednall, Marshall, Greenfield, Curlow, Stephenson, Webb, Brain (with the wooden leg), Elliot, Brain, Sheard, Cook, Warewell, Jackson, Martin, Griffiths, Rudge.

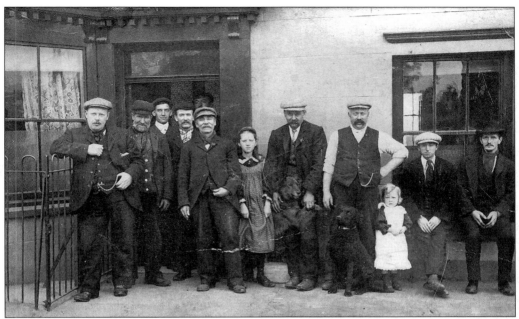

The regulars gather outside the Horse and Jockey public house: From left to right: -?-, -?-, -?-, -?-, H. Bednall, E. Robinson, T. Robinson, Arnold, D. Arnold (the small girl), N. Marsh, -?-.

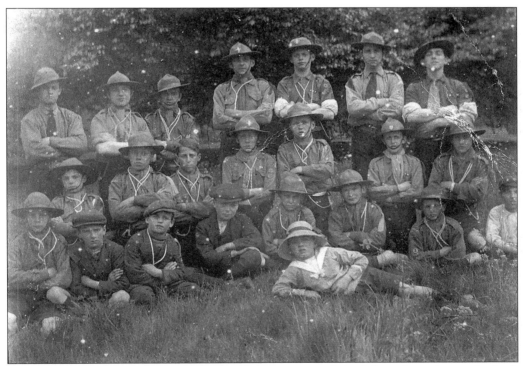

The Altofts Scout group of 1916. T. Shackleton is pictured third from the right on the back row.

The Bing Boys in the 1920s. These young men dressed in the height of fashion and entertained listeners with their banjos. Among the six are: J. Balgue, W. Sadler, H. Lacy, B. Bromby, B. Bellwood.

This group of young people sang and danced. Back row, from left to right: R. Driver, G. Eccles, G. Hopwood. Middle row: C. Taffinder, O. Wilby, E. McDonald. Front row: S. Brooks, E. McDonald, D. Marshall.

Women's Institute Choir. Among those pictured are: Betts, J. Harris, Ransom, Heseltine, McAndrews, Baggat, Mason, Slatcher, Newton, Mr Nelson, Senior, Glover, Smith.

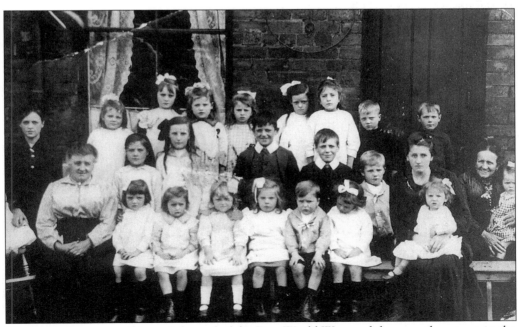

Wentworth Terrace celebrated the end of the First World War, as did every other street in the town.

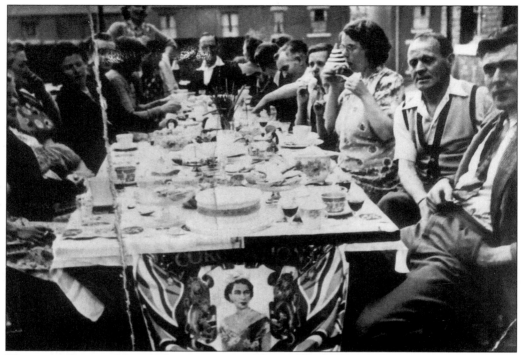

Thompson Street celebrates the coronation of Queen Elizabeth.

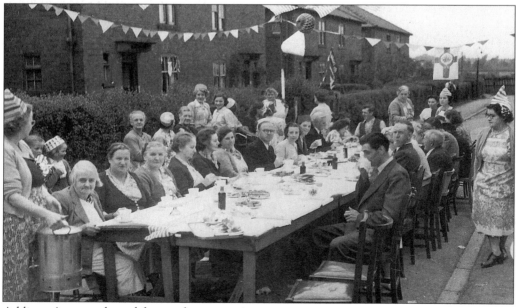

Addison Avenue also celebrates the coronation.

The Pritchard Family. Many families had lost husbands, fathers or sons during the World Wars. Four of the Pritchard brothers were killed in the First World War.

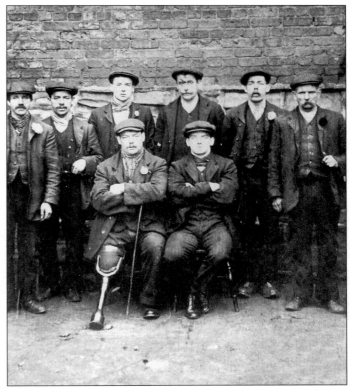

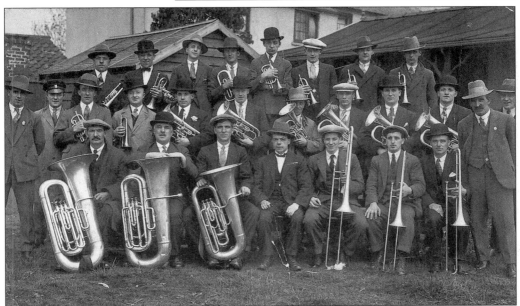

Altofts Colliery Band. Back row, from left to right: -?-, -?-,Wilf Bednall, -?-, J. Turner, -?-, C. Hancock, ? Plimmer. Middle row: W. Cresswell, -?-, A. Crossland, R. Taffinder, ? Bastow, J. Mears, A. Lewis, -?-, A. Shepland, Z. Cooper, -?-. Front row: ? Crossland, ? Cadman, -?-, ? Cadman, ? Walsh, ? Forester, -?-, ? Flintoff.

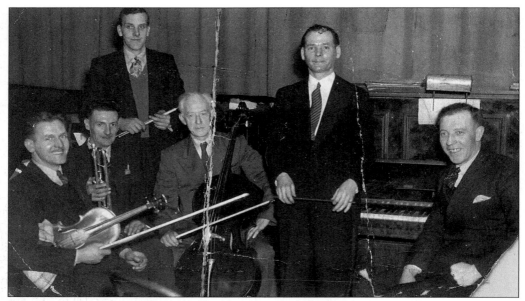

This band played in the local halls after the Second World War. Pictured are: N. Firth (standing at the back) and, from left to right; J. Millington, C. Hancock, A. Byrns, J. Dowton, B. Penny.

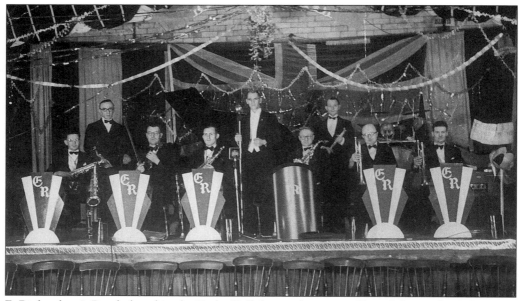

E. Richardson's Band played in the Baths Hall during the winter. From left to right: J. Biggs, T. Boardman, W. Page, J. Layton, C. Pallester, W. Bradshaw, E. Richardson, R. Taffinder, C. Hancock.

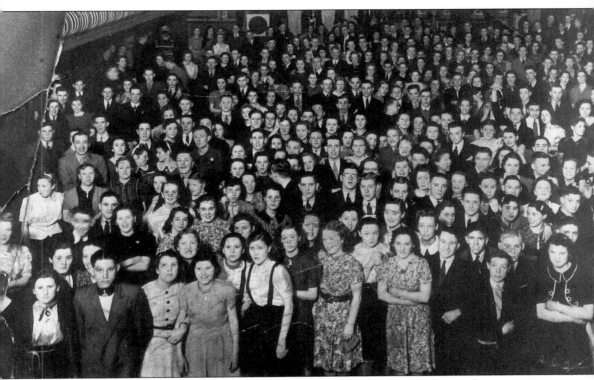

The Saturday night dance in Normanton Baths. A wooden floor was laid over the swimming pool in the winter so that it could be used as a dance floor. During the period from 1920 to 1970 many romances started here at the weekly dance.

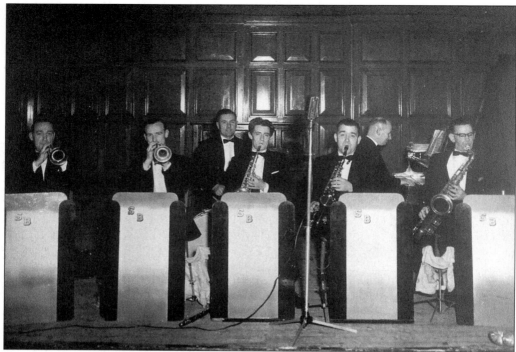

D. Wilkinson's Band in 1949. Pictured from left to right are: A. Thornton, S. Brockdale, -?-, -?-, D. Walker, D. Wilkinson, J. Biggs.

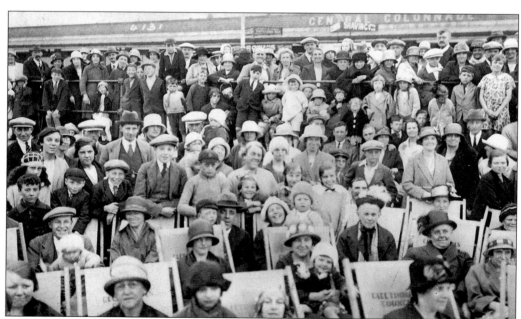

Slowly the railways made visits to the coast available to ordinary working people. A local lodge, the Rechabites, arranged this trip to Cleethorpes in 1923. The Brown family can be seen to the right of centre.

As wages improved people could afford to go to the coast for more than just a day trip. The Boyes family are pictured on holiday at Cayton Bay sometime before the Second World War.

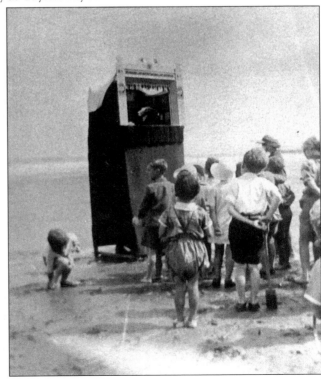

For over one hundred years Normanton's children have enjoyed the seaside Punch and Judy shows.

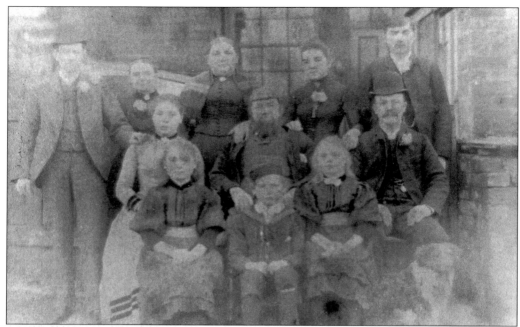

The local public houses often organised celebrations for local and national events. This is the Stringer family in 1860. They managed the Miners Arms. Back row, from left to right: Mr Plimmer, Mrs Plimmer, Sarah, Emma and G. Stringer. Middle row: Elizabeth Stringer, Mr Stringer, Dan Baker. Front row: Ada, Roland and Elizabeth Stringer.

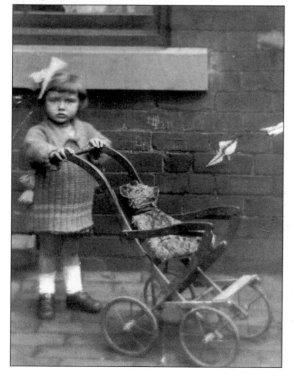

Children of wealthy families played with teddy bears in push chairs. Miss Olive Banks is pictured in the garden of her family home. Olive later managed an ironmonger's shop in the town for many years.

The children of less wealthy families built their own bikes. These are the Dixon brothers, Jack and Jim.

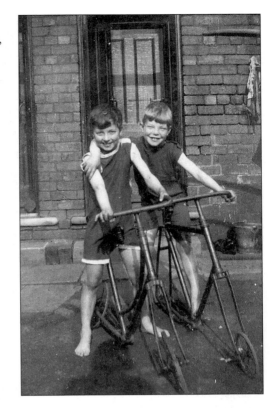

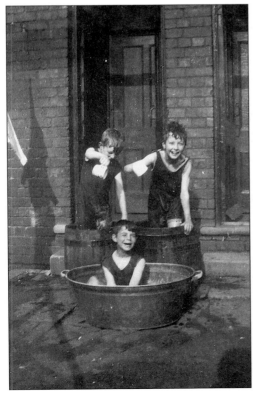

The Dixon brothers and friends used wooden tubs and the tin bath as paddling pools.

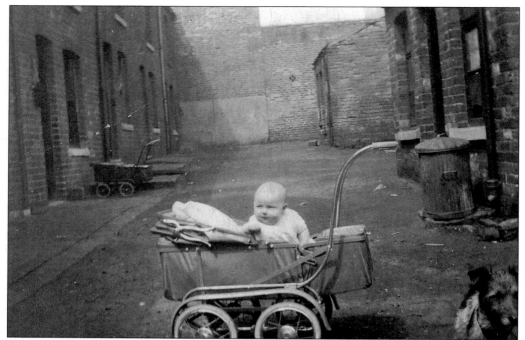

Many homes had no gardens, so children would play in the traffic free streets. Here in Templar Street is baby Alyn Pugh.

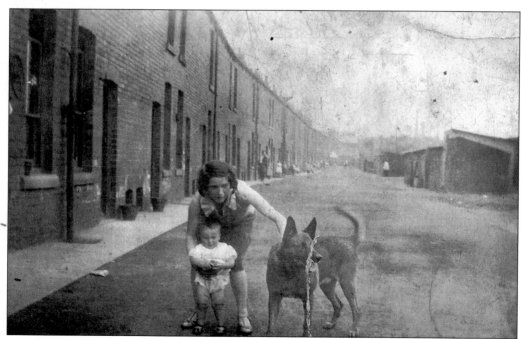

Mrs Blayton, with baby and dog.

This is a rare (and unfortunately quite badly damaged) photograph of the Midland Hotel prior to 1900. On the left a large notice advertises the Gala.

Looking along the arcade, at the side of the Midland Hotel, towards the market stalls in 1900. Mr Hampson and friends stand under a banner celebrating a national occasion. Mr Hampson's son, Walter, wrote books in the Yorkshire dialect.

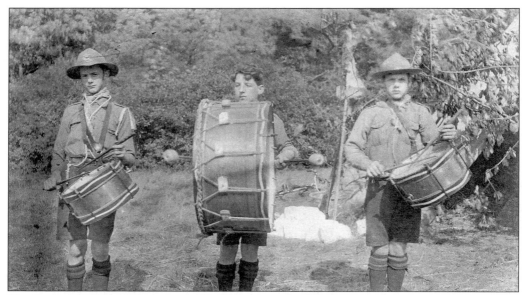

The Scouts made their own music. W. Kaiser is on the left.

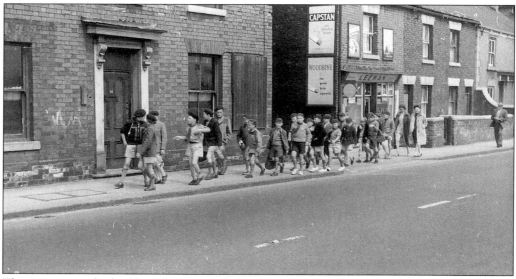

This is a group of cubs. Here they are exploring Normanton.

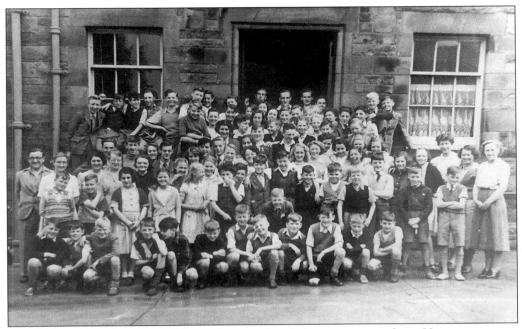

Churches in the area arranged annual camps for their younger members. Here a group are pictured on a trip to Edinburgh in 1951. Mr S. Tomlinson stands on the extreme left, Miss Brown is at the extreme right.

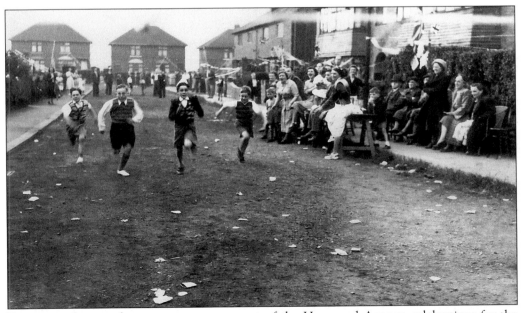

Young people race along empty streets as part of the Harewood Avenue celebrations for the coronation of Queen Elizabeth.

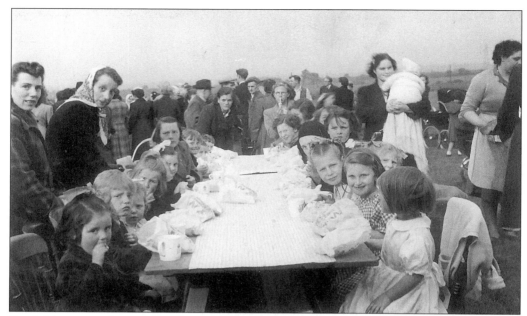

Snydale's coronation party. Among those pictured are: M. Pritchard, B. Webster, A. Hutchinson, C. Farrell, M. Farrell, B. Hemmingway, C. Hemmingway.

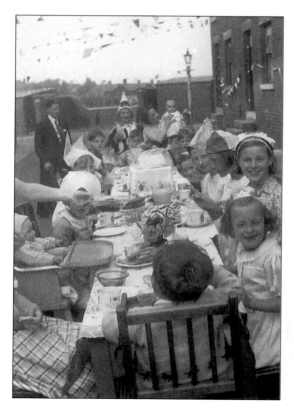

This is a coronation party in St Johns Terrace. Notice the toilets at the bottom of the street. Those enjoying the party include: J. Ashurst, S. Woodcock, A. Hughes, A. Callaghan, G. Woodcock, J. Durkin.

Six
Fashion

The wealthier people of the town dressed up in the fashionable clothes of the day on special occasions.

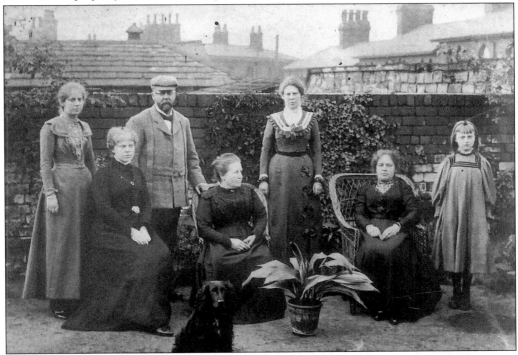

Normanton stationmaster, Mr Burley and his family. Dr Twist married one of his daughters.

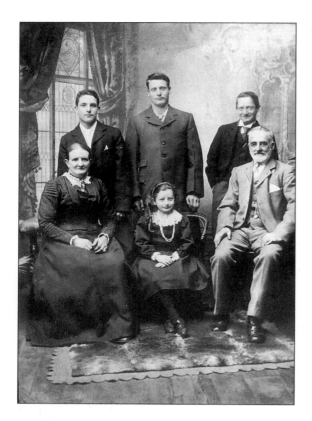

The Wilkinson family in the 1920s.

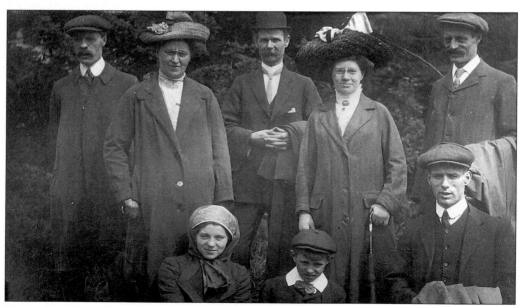

Walter Hampson (centre) is surrounded by members of the Eccles family in 1913. Walter wrote the first book on the history of Normanton.

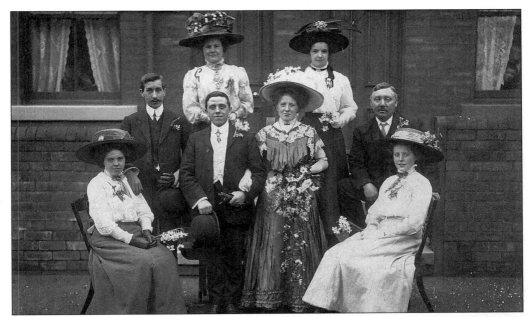

Harry Brooker and Alice pose for their wedding photograph. G. Hampson is the gentleman on the left.

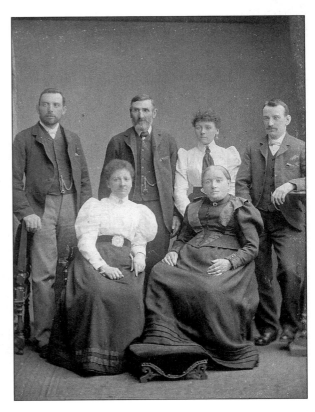

Thomas Erasmus Cressy and family.

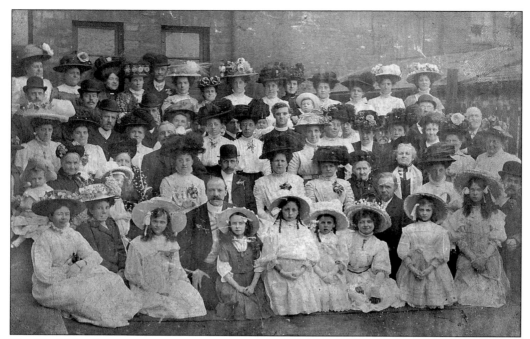

The Heald family.

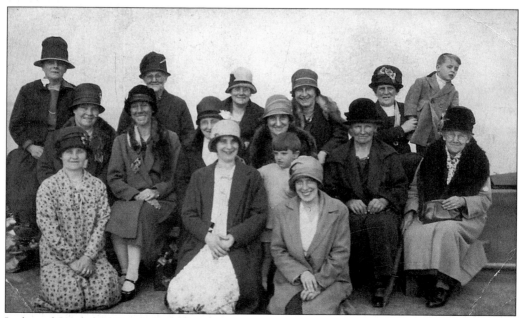

Ladies of Castleford Road chapel.

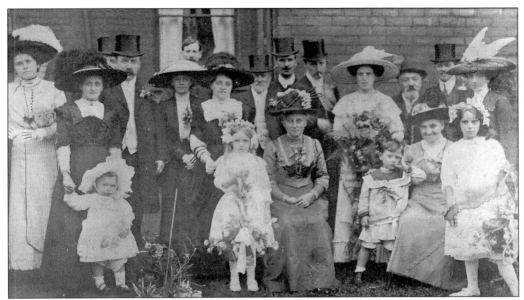

The wedding of local schoolmaster, Leonard Tiffiny, in 1911. Leonard taught in several local first schools.

A Mopsey Square family pose in their doorway.

Pictured from left to right are: Mrs Dixon, M. Shearn (standing), Mr F. Oakley, Mrs F. Oakley, S. Oakley (standing), Mr Dixon.

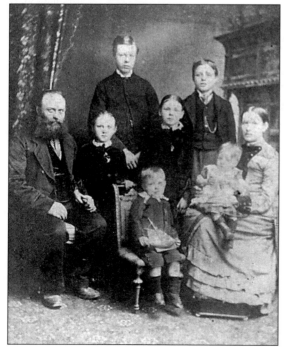

The Eccles family.

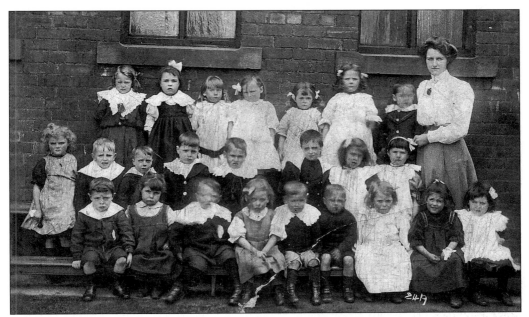

Note the children's fashionable clothes, in this class at Normanton Common School, in 1910. Mrs Tomlinson is the teacher.

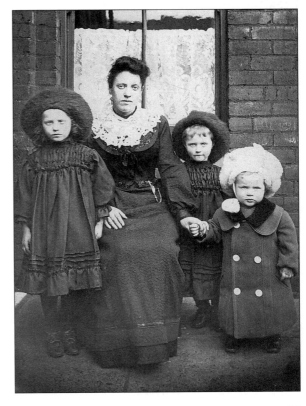

E. Buckle and family.

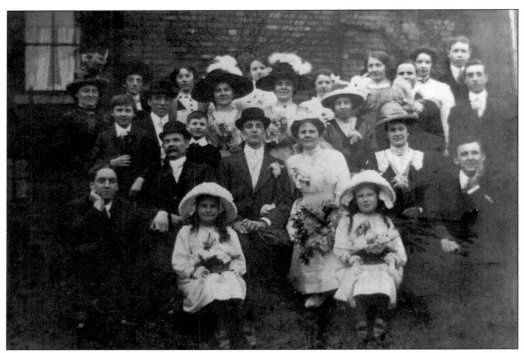

The wedding of Gertie Hampson.

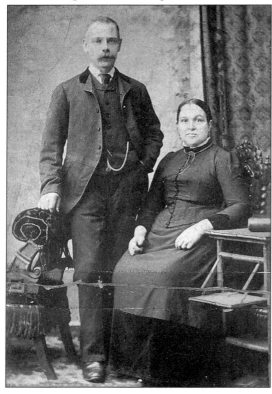

Mr and Mrs Westwood. Mr Westwood was a captain in the Salvation Army.

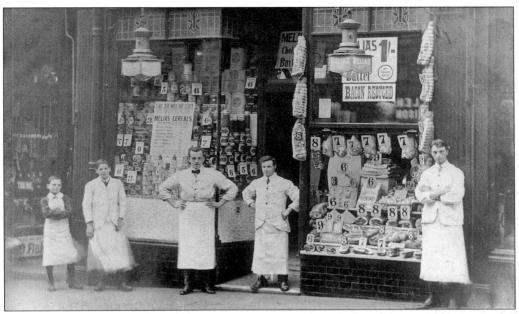

Melias' shop in the High Street. Note the smart attire of the shop assistants.

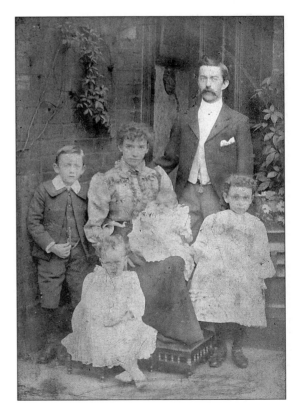

Mr and Mrs Hall and family. A helpful comment on the back of this studio portrait reads 'this photograph can be finished in oils, water colours or crayons'.

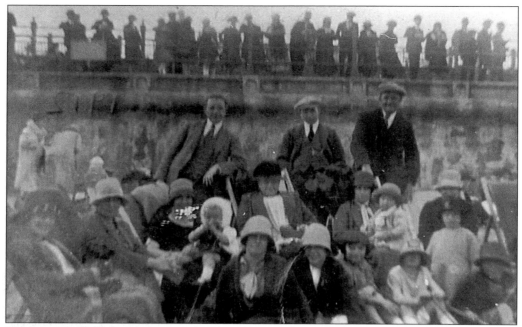

Shop owners and assistants on a day out. Among those pictured are: F. Busby, F. Simmons, Bryant, Mrs Westwood, A. Moorhouse, Mrs Busby, Mrs Young.

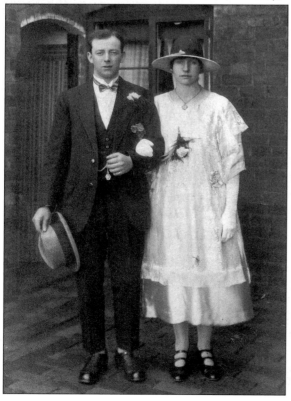

Mr and Mrs R. Langley of Co-operative Street, Hopetown.

Violet Wilson from Loscoe, ready to go to work in 1920.

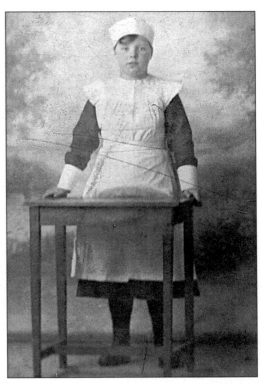

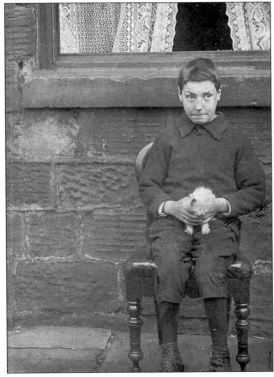

Jimmy White sits in the street in St Johns Terrace in the 1920s.

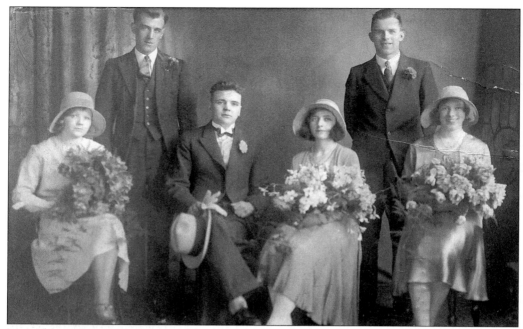

Mr and Mrs Newton on their wedding day.

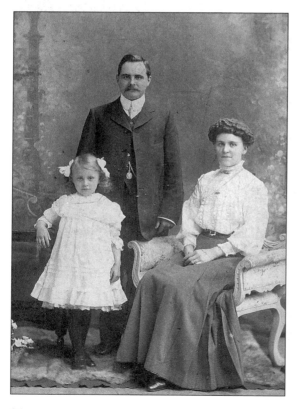

The Shenton family in 1910. They lived in Garden Street, Altofts.

Seven

Sport

Sport played a major role in the social life of the town. Many different sports were enjoyed. As the teams from all corners of the town competed against each other, thousands would watch, so bringing together the people of the town.

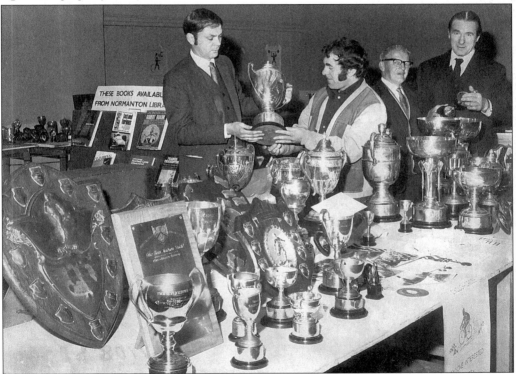

Many were surprised at the number of trophies won by local people. The Normanton Sports Advisory Council organised this exhibition in the 1970s to demonstrate the sporting prowess of residents. B. Fraser (secretary) is showing D. Miles a trophy, watched by H.L. Moody and M. Exley (president).

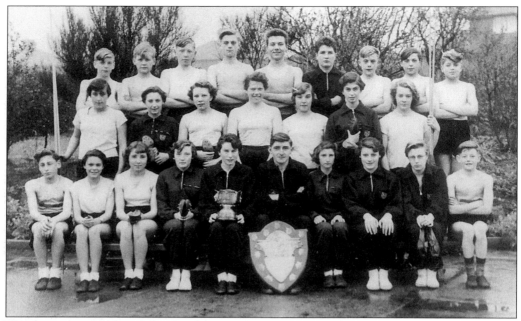

The Secondary Modern School Athletics Team in 1956. Back row, from left to right: E. Paul, M. Snell, I. Burnell, B. Appleyard, H Robinson, G. Dunn, B. Walker, A. Parfitt, J. Buttery. Middle row: M. Crossley, A. Jenkins, J. Bacon, M. Evans, J. Swift, D. Tate, P. Morgan. Front row: D. Auty, P. Byram, S. Vause, C. Lythgoe, C. Caney, D. Wilby, S. Turner, J. Firth, D. Woodcock, K. Williams.

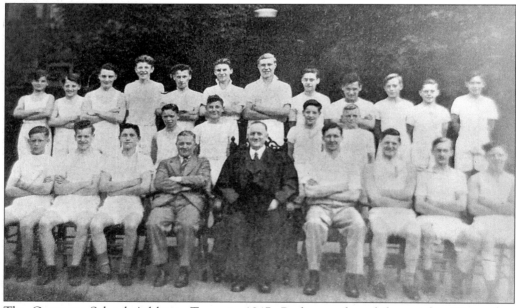

The Grammar School Athletics Team in 1947. Back row, from left to right: Womersley, Nichols, Heaton, Lumb, Moverlay, Rushton, Mortimer, Blakeway, Valentine, Lawson, Devey, Haycock. Midle row: Price, Westwood, Kirk, Hodgson. Front row: Smith, Ward, Tordoff, Mr Young, Mr J.A. Holden (headmaster), Mr Atter, Garner, Astley, Parkinson.

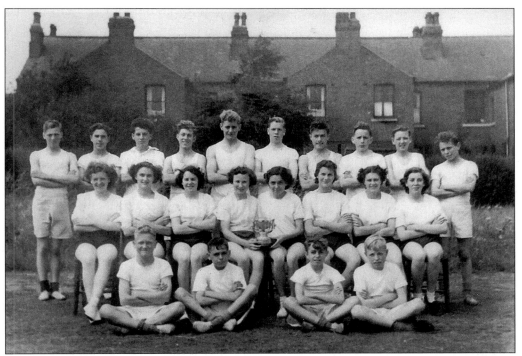

A mixed Grammar and High School team. Among those pictured are: D. Devey, C. Copley, N. Atkinson, D. Miles, D. Lumb, G. Ellis, D. York, J. Green, R. Kilburn, York, C. Tucker, Deakin.

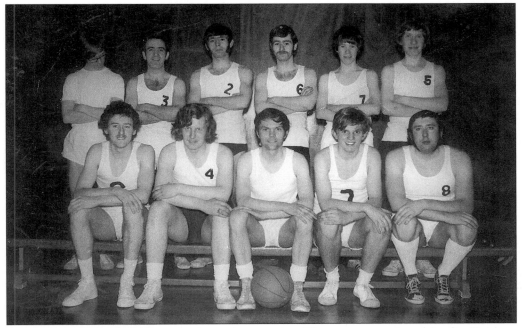

Altofts Aces Basketball Team in the early seventies. They were mentioned in the *Guinness Book of Records* until 1996. Back row, from left to right: -?-, A. Stuart, T. Dyson, T.J. Dyson, M. Beckitt, -?-. Front row: L. Ward, -?-, B. Fraser, D. Wales, B. Shingles.

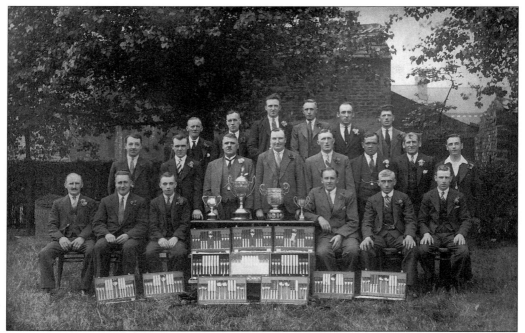

A. Hurley, Benton, Bednall, Carter, Hargreaves, Dinsdale and Hallas, along with other members of the Lee Brig WMC Billiard Team, show off their trophies in 1927.

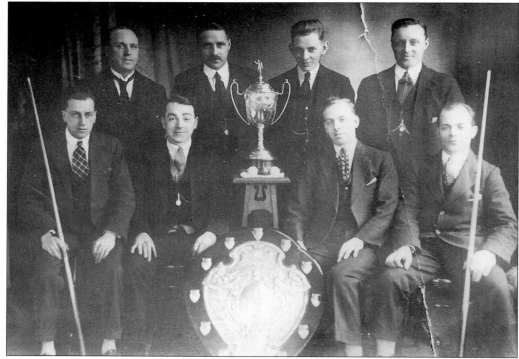

E. Pearson, M. Jollife, Turner, H. King and others of the Liberal WMC Billiard Team display the LMSR Shield in 1928.

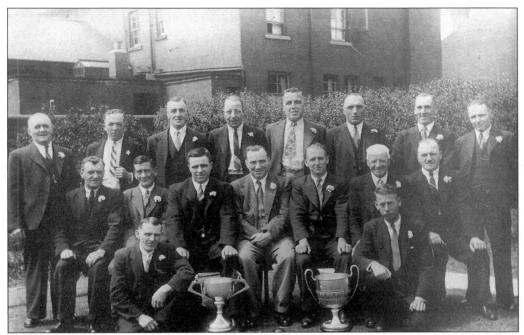

Carlton WMC in 1944, with the Wakefield Cup. Back row, from left to right: Armstrong, J. Mason, J. Cuniff, J. Gill, J. Jones, J. Bolton, B. Smith, J. Grinsill. Middle row: J. Marney, F. Smith, T. Lethbridge, F. Wilby, A. Herberts, Bleisman, H. Caswell. Front row: W. Rhodes, W. Cusworth.

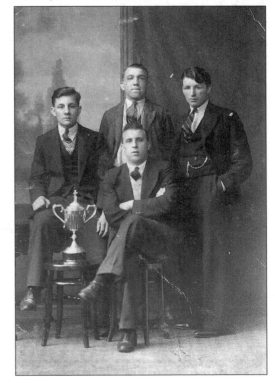

In 1932 George Williams (left) won this cup on the feast ground. The other Normanton boxers shown are H. Mason (back) B. Bennet (right) and F. Johnson (front).

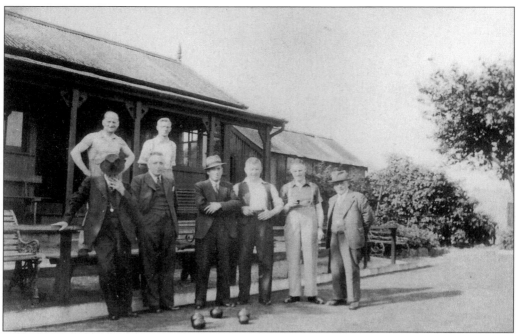

Normanton Bowling Club. Included among those pictured are B. Benson, J. Smith and R. Busby.

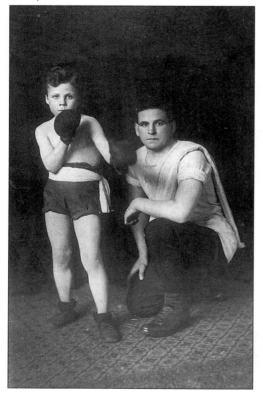

Young Curlie Williams and Harry. Curlie fought in forty-seven bouts in the period from 1928 to '32, mostly over ten or twelve rounds and often against much heavier opponents. He only lost four.

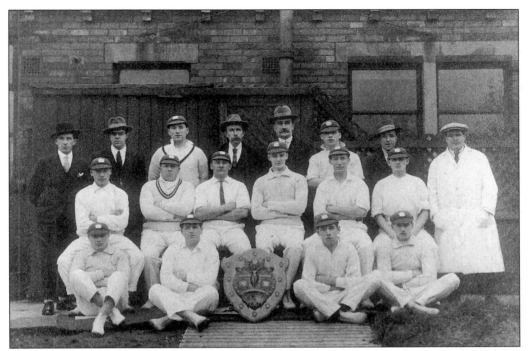

Normanton Railwaymen's Cricket Team. Among those pictured are: M. Limb, P. Poole, J. Rodney, Limb, A. Shepherd, Goldthorpe, D. Allen, N. Hinchliffe.

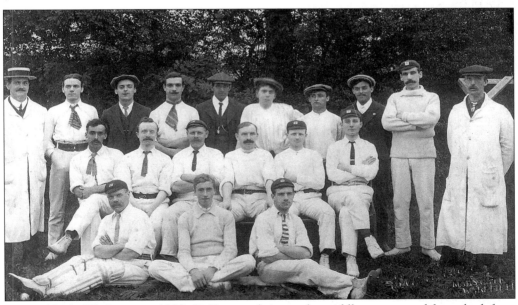

Upper Altofts Wesleyans in 1910. G. Hopwood sits on the middle row, second from the left.

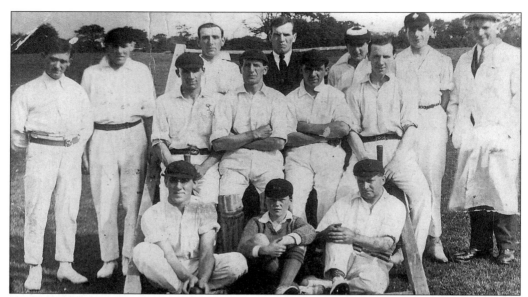

Altofts Lock Lane (Primitive Methodist) cricket team, 1920. Back row, from left to right: T. Walley, A. Golby, F. Kellet, H. Radcliffe, E. Slack, T. Senior, W. Radcliffe (umpire). Middle row: M. Sykes, J.W. Clark, A. Hurley (captain), H. Sykes. Front row: E. Kellet, -?-, W. Ransome.

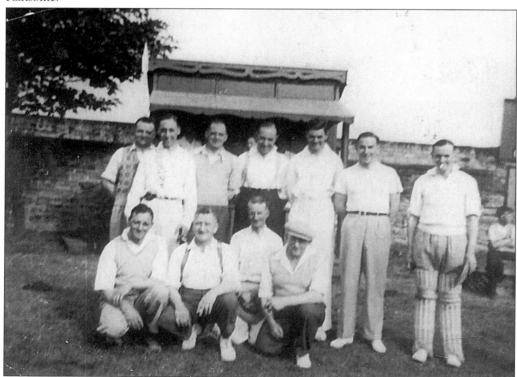

St Johns Colliery team. In 1937 they played at Heath Common. Among those pictured are: J. Brannen, G. Abbot, A. Kerr, Sydney, Maguire.

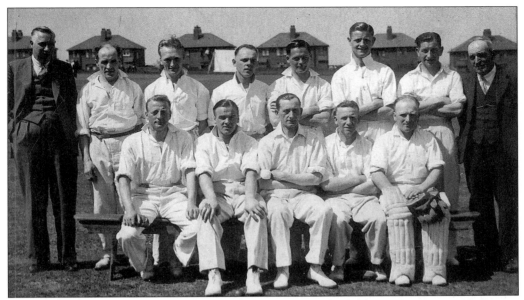

Altofts Welfare in 1939. Among those pictured are: G. Schofield, W. Armstrong, N. Driver, ? Armstrong, T. Bednall, A. Jones, J. Deakin, ? Waring, G. Bednall, ? Armstrong.

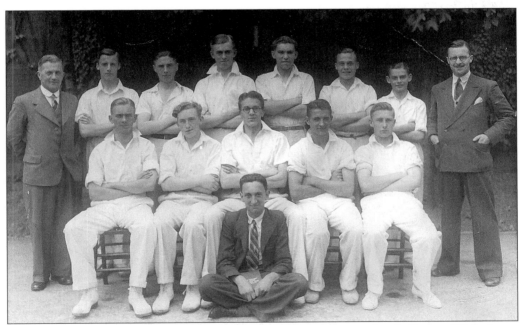

Grammar School First Eleven in 1940. Back row, from left to right: J. Young, W. Jackson, G. Nelson, C. Woolford, K. Bullimore, R. Price, E.J. Rollin, R. Law. Middle row: G. Downing, R. Wood, K. Bunmored, ? Atack, W. Ward. Front: K. Whalley.

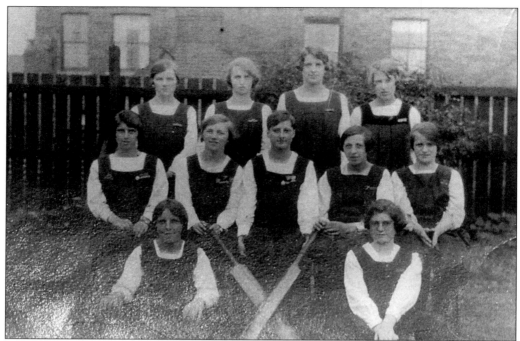

Normanton High School Ladies Cricket Team: Back row, from left to right: D. Senior, J. Travis, D. Whittingham, P. Denison. Middle row: W. Fosey, D. Smith, P. Haslam, E. Kappes, ? Shaw. Front row: ? Jackson, D. Kershaw.

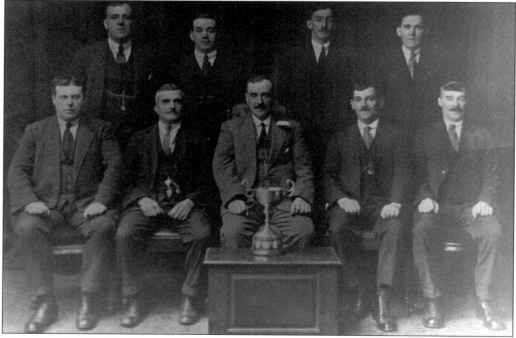

Hopetown WMC Crib Team, 1920. Back row, from left to right: B. Bradford, H. Gledhill, J. Babb, H. Eseldine. Front row: J. Burns, ? Mosby, A. Hardcastle, J. Bourne, F. Higgins.

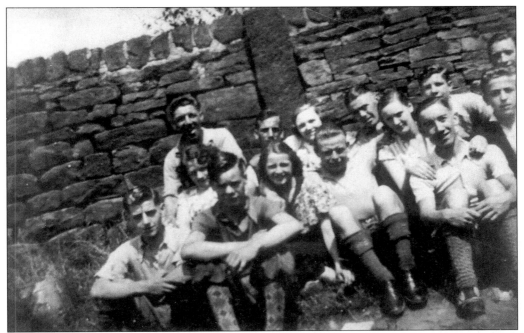

Cycling was always a popular sport. These young people were members of the Good Hope Wheelers cycle club in 1926.

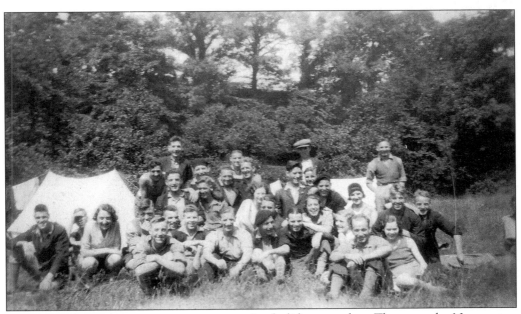

Sometimes the cycling groups went on camping holidays together. These are the Normanton Star Wheelers in 1931.

Netball was also a popular sport. This is the Dodsworth School team in 1934, from left to right: M. Johns, C. Williams, E. Stark, D. Reynolds, S. Booth, I. Reynolds, A. Crawshaw.

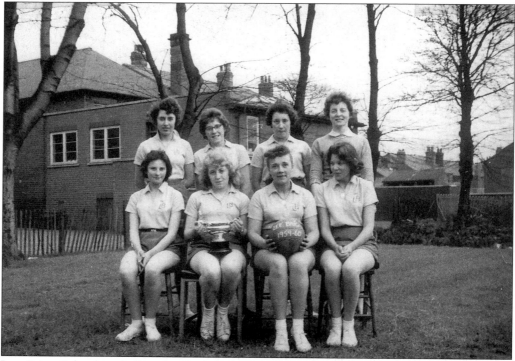

Lee Brigg School netball team. Back row, from left to right: M. Woolley, B. Bennett, A. Webster, S. Schofield. Front row: M. Yates, L. Brain, C. Swift, M. Hardy.

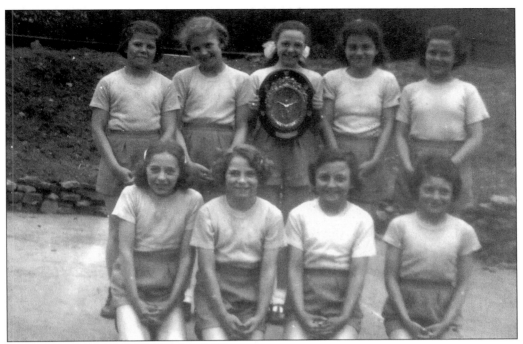

A team from the Church School in 1950.

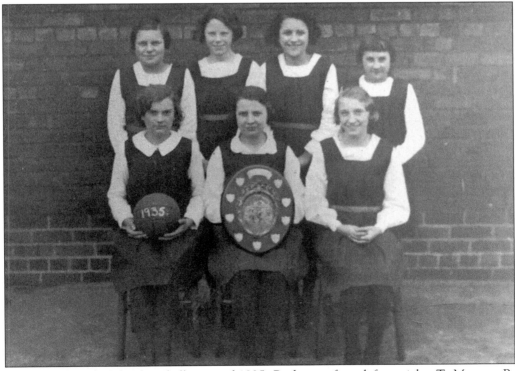

Normanton High School netball team of 1935. Back row, from left to right: T. Morton, R. Bubb, C. Lakin, M. Hardwick. Front row: I. Turner, E. Hudson, C. Bulby.

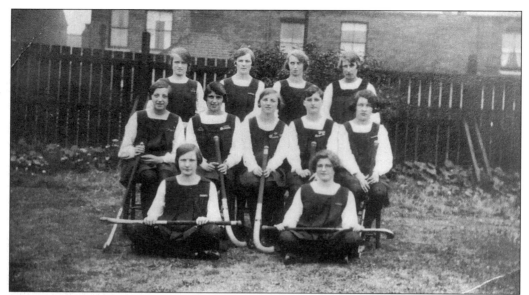

High School hockey team in 1924. Back row, from left to right: W. Jarvis, A. Dunkley, M. Hudson, Miss Griffiths. Middle row: F. Blackburn, M. Eaton, M. Newton, D. Druce, D. Lodge. Front row: L. Thorpe (who played for Yorkshire), M. Shaw.

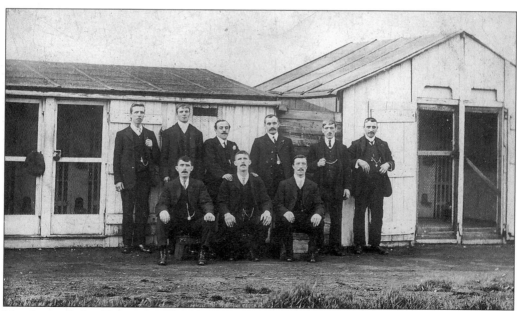

Members of the Hopetown Homing Association (pigeon racing) in 1906. Among those pictured are: W. Pickles, A. Mitchell, J, Westwood, T. Westwood.

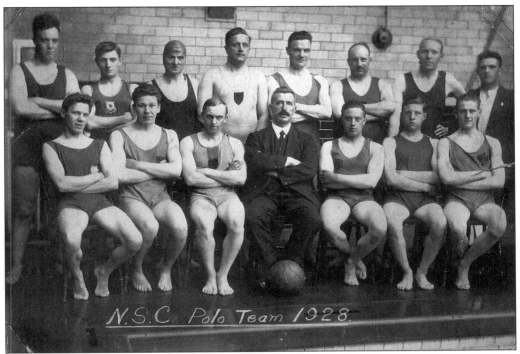

Normanton water polo team in 1928. Back row, from left to right: H. Edwards, C. Appleby, ? Teal, H. Stables, ? Cartwright, ? Gilderdale, ? Croft (headmaster of Lee Brigg School), B. Shackleton. Front row: A. Appleby, A. Bryant, L. Rose, Dr Mckay, W.F. Holt, N. Atkinson, H. Bates.

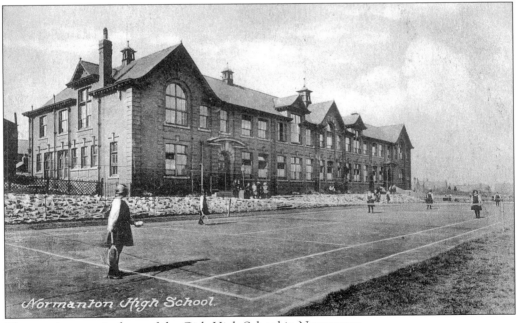

The tennis courts in front of the Girls High School in Normanton.

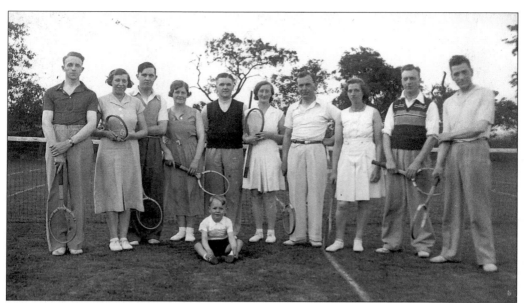

Altofts Welfare Tennis Club in the 1930s. Among those pictured are Mr and Mrs Archer, Mr and Mrs C. Welsby, Mr and Mrs Morrel, Mr and Mrs Firth, D. Proctor, R. Taffinder.

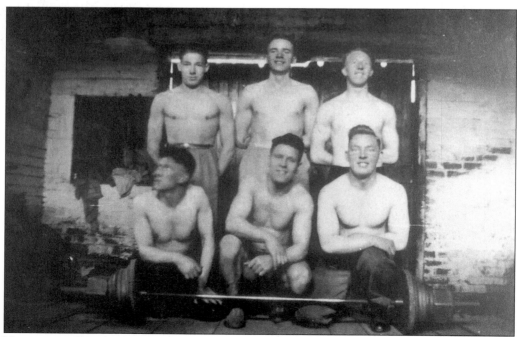

Normanton Weight Training Club. Back row, from left to right: V. Sykes, T. Dunn, H. Chapman, E. Bowden, C. Phelps, A. Burton.

Eight
Football and Rugby

These winter sports were watched by large crowds and feelings sometimes ran high at matches between local teams. Many playing these sports later joined professional teams.

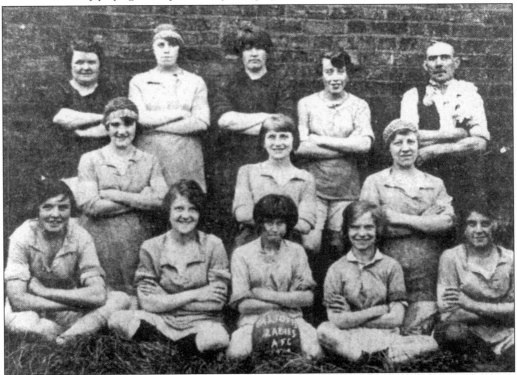

This ladies football team was formed to raise money to help striking miners in 1926. Back row, from left to right: P. Turner, E. Timmins, P. Tomlinson, A. Fisher, Mr J. Pagett (trainer). Middle row: H. Tomlinson, ? Rushton, B. Plant. Front row: A. Smith, K. Limb, K. Megson, M. Speak, E. Jones.

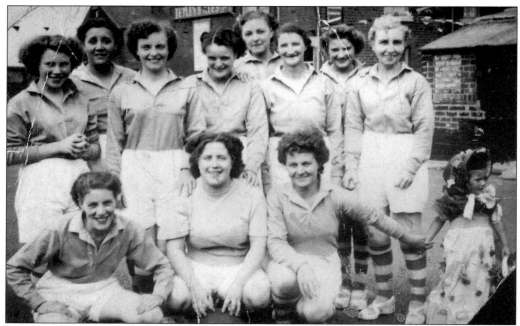

This ladies team played in 1948. The team comprised M. Turner, M. Davies, M. Ridge, G. Dixon, V. Dunn, ? Ildridge, J. Webster, ? Ridge, ? Stringer, B. Cain, E. Corbett, Mrs Rodgers and daughter. On the day of the photograph one of the ladies was not present.

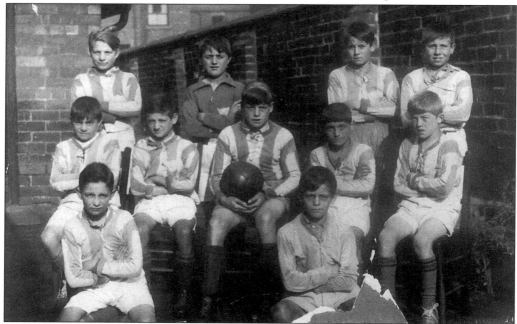

Football has been played between the schools of the town for almost one hundred years. This is Loscoe School's team in 1932. Back row, from left to right: R. Windross, S. Webster, R. Rushton, J. Dixon. Middle row: G. Holland, E. Rushton, D. Crewe, J. Price, E. Holland. Front: A. Newton, G. Dawson.

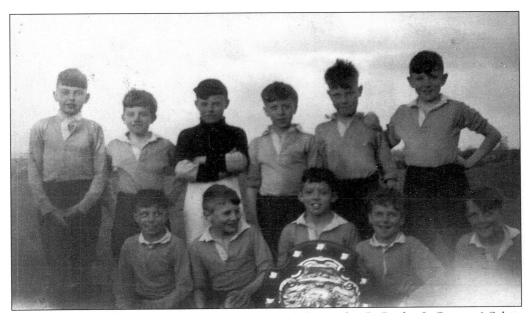

Woodhouse School team in 1950. Back row, from left to right: B. Banks, J. Govan, ? Sykes, B. Bullough, D. Smith, D. Auty. Front row: -?-, A. Bell, I. Atkinson, B. Milner, G. Oliver.

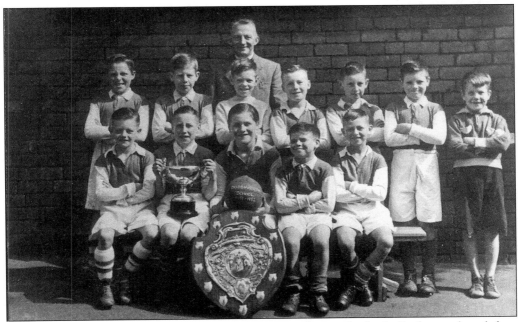

Dodsworth School team in 1951. Mr S. Barnett is standing at the back. Back row, from left to right: H. Bailey, R. Taylor, J. Fountain, M. Taylor, F. Wainwright, J. Butterfield, M. Jordan. Front row: K. Williams, F. Westwood, B. Bryant, W. Robinson, G. Wainwright.

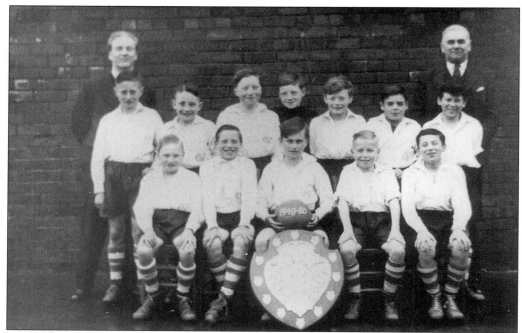

Church School team in 1949. Mr Gullick and Mr Mason stand at the back. Back row, from left to right: G. Appleyard, B. Abson, M. Dixon, P. Crossland, C. Whales, G. Allan, J. Sykes. Front row: J. Hunt, D. Stokes, G. Buckley, J. Jeffries, M. Whittaker.

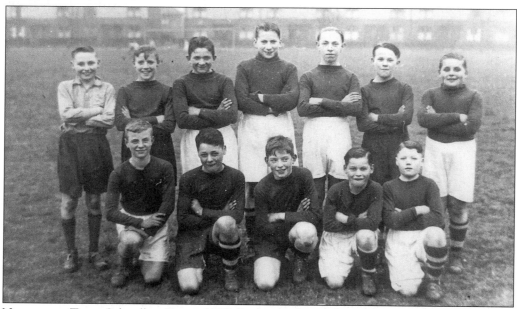

Normanton Town Schoolboy Team, 1938. Back row, from left to right: L. ward, ? Jackman, H. Dunn, T. Atherton, J. Dye, B. Deakin, W. Stanley. Front row: ? Sykes, A. Mosby, J. Madely, J. Swift, E. Dunn (who later played for Sunderland FC).

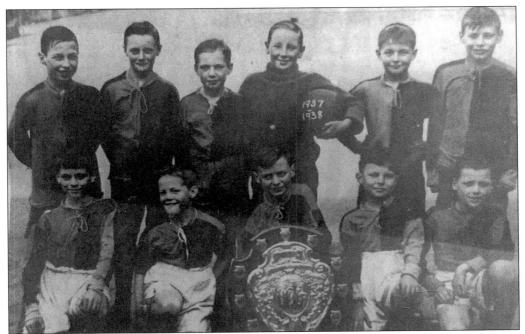

Queen Street School, 1937. Among those pictured are: R. Carter, A. Webb, S. White, E. Parfitt, M.K. Paver, E. Downing, B. Stones, G. Bucklow, H. Higgins.

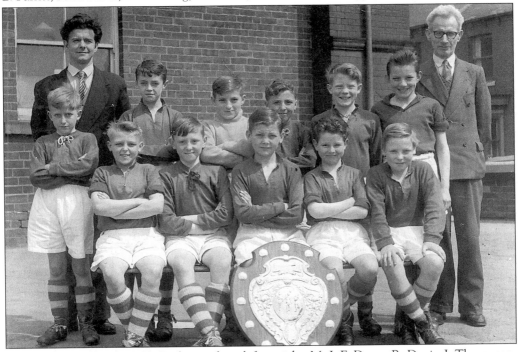

Queen Street School, 1955. Back row, from left to right: Mr L.F. Darcy, R. Davis, J. Thompson, B. Williams, J. Chapman, I. Vaughan, Mr J. Beadle (headteacher). Front row: G. Ball (standing), G. Day, I. Burnell, M. Snell, B. Cahill, D. Lumb.

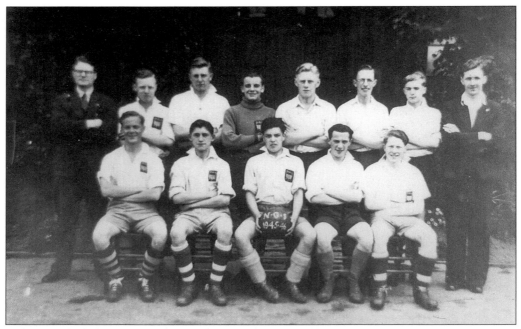

The Grammar School team in 1945. Back row, from left to right: Mr Shoulders, J. Stych, C. White, R. Schoffield, ? Robinson, G. Griggs, D. Nightingale, Mr Hatter. Front row: B. Stones, G. Tordoff, S. Frost, ? Hawkins, K. Banks.

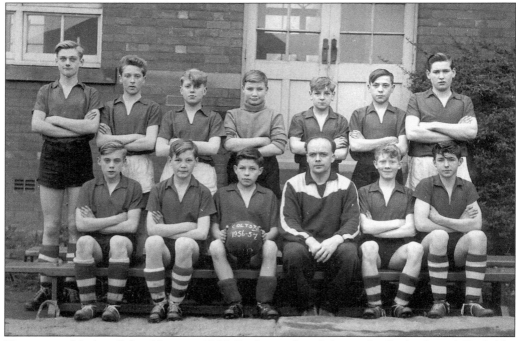

Normanton Modern School Juniors, 1955. Back row, from left to right: B. Appleyard, D. Cable, J. Buttery, G. Lavinton, J. Fearnley, A. Parfitt, D. Whitcombe. Front row: B. Walker, M. Snell, A. Scott, Mr Stubbs, J. Chapman, K. Eades.

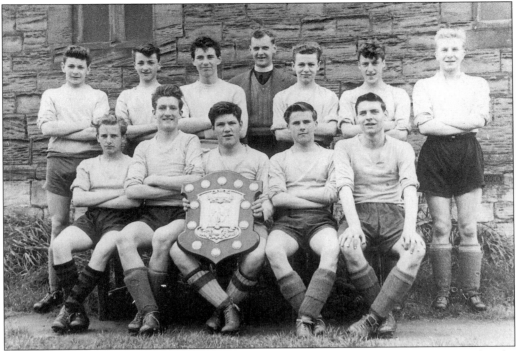

The Church Youth Club in the 1950s. Back row, from left to right: B. Hardcastle, D. Thompson, S. Close, Mr Lindley, R. Bolton, G. Burden, C. Tucker. Front row: H. Massey, D. Bradley, D. Leak, M. Hough, K. Blakeway.

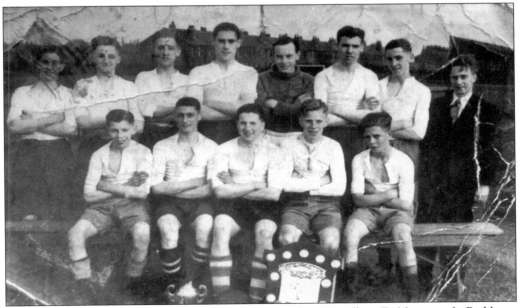

Altofts Juniors in 1937. Back row, from left to right: ? Bradley, E. Newton, J. Beddows, ? Ratcliffe, M.A. Bennet, ? Slater, B. Toddington, J. Cooper. Front row: A.J. Glazard, W. Burrows, W. Pell, H. Mosby, A. Jones.

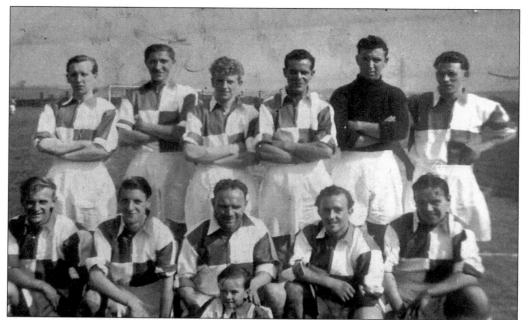

Many different teams played throughout the years. Some were in existence for many years others, like this team, St Johns, disbanded as the community disappeared. Back row, from left to right: -?-, B. Towler, J. Taylor, G. Golding, G. Kew, J. Jubb. Front row: R. Sykes, D. Lee, ? Carter, J. Morley, R. Golding.

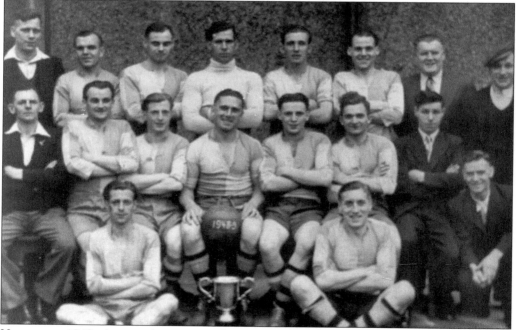

Hopetown, 1948. Among those pictured are: J. Mason, T. Lethbridge, J. Wright, J. Dooley (landlord), S. Pell, A. Bellwood, F. Appleyard (captain), S. Arnold, ? Dunn, J. Collinson (sitting at the front), J. Berry, A. Long.

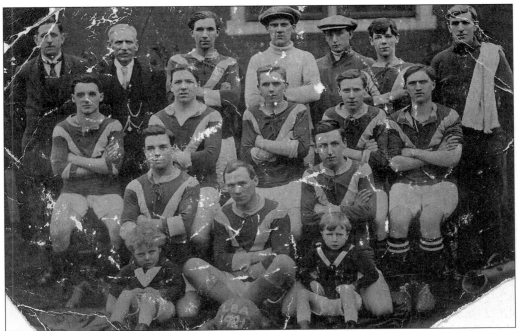

Jockey Hornets in 1921. Those pictured include: S. Frith (goalkeeper), S. Powell, ? Powell, S. Plummer, N. Schofield, S. Griffiths, G. Reed.

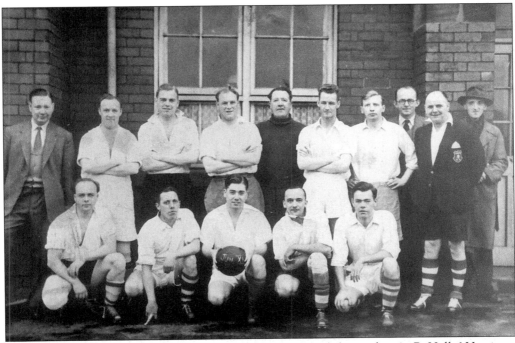

Secondary Modern school teachers in 1956. Back row, from left to right: -?-, B. Hall, ? Harrison, B. Burgess, G. Chafer (school gardener), -?-, D. Carey, D. Jones, -?-, V. Beadle. Front row: L. Stubbs, J. Westmorland (caretaker), -?-, L. Wilson, ? Gilby.

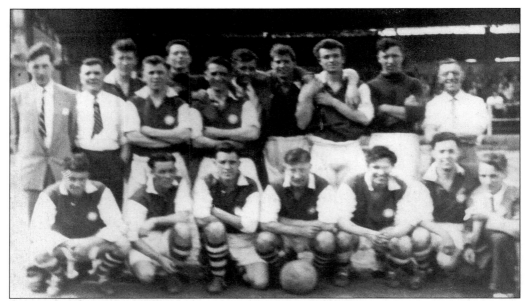

This Normanton Team played several matches in Paris in 1955. Back row, from left to right: J. Beddows, D. Bettney, -?-, P. Wilby, K. Robinson, G. Kew, F. Barratt, K. Holmes, -?-, R. Williams, J. Dyson. Front row: L. Gordon, J. Jubb, R. Davies, L. Jones, F. Dixs, R. Bott, -?-.

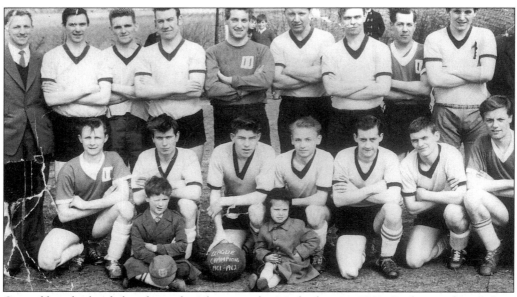

One of hundreds of church or chapel teams; the Methodists in 1961. Back row, from left to right: H. Parkinson, A. Parfitt, K. Allchurch, V. Wood, J. Bartram, G. Kew, B. Brain, C. Driffield, P. Cartwright. Front row: S. Dunn, C. Bellwood, A. Lowe, L. Scott, C. Brain, B. Morgan, B. Allington, R. Holt, F. Barratt (trainer).

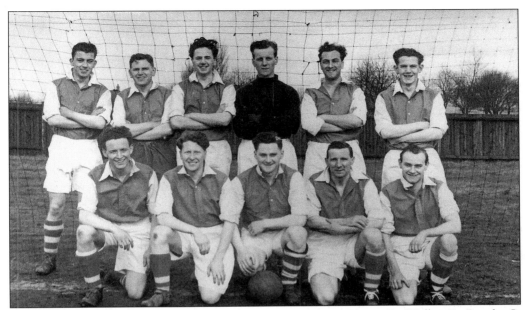

Old Frestonians. Back row, from left to right: J. Kappes, J. Short, R. Walby, B. Brook, C. Linford, ? Glazard. Front row: J. Freeston, C. Banks, M. Akers, J. Beddows, D. Warrington.

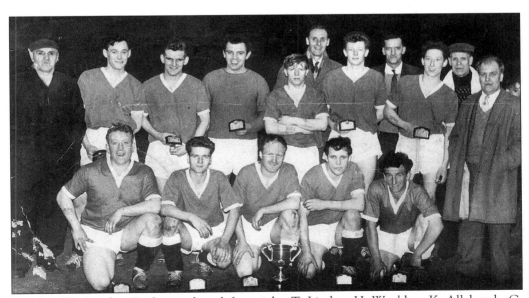

St Johns Wednesday. Back row, from left to right: T. Lindop, H. Weeldon, K. Allchurch, G. Allchurch, S. Taylor, B. Cocker, L. Sykes, T. Green, T. Dean, J. Hodgson, J.J. Armstrong. Front row: R. Grinsel, B. Miller, E. Jones, R. Davies, B. Sambrook.

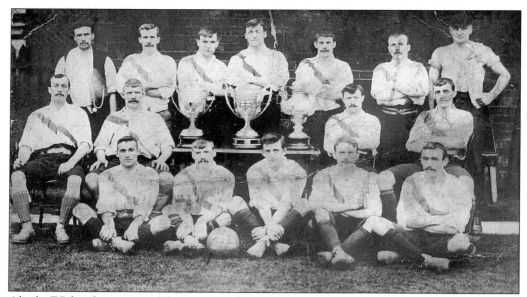

Altofts FC has been around for over one hundred years. This is the team of 1903. Back row, from left to right: T. Hatherton, T. Williams, J. Blankley, J. Dye, -?-, W. Taylor, J. Beavors (trainer). Middle row: ? Wales, C. Hopson, H. Jones, B. Jones. Front row: F. Timmins, W. Edwards, G. Lindop, W. Webb, D. Edwards. They were winners of the West Yorkshire Cup (centre) for three successive years.

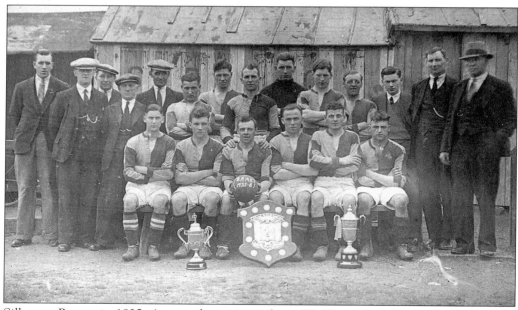

Silkstone Rovers in 1935. Among those pictured are: W. Timmins, J. Evans, A. Herberts, P. Scaife (goalkeeper), ? Webb, J. Hartley, E. Rooker, B. Weldon (captain), P. Whitlam, H. Weldon.

122

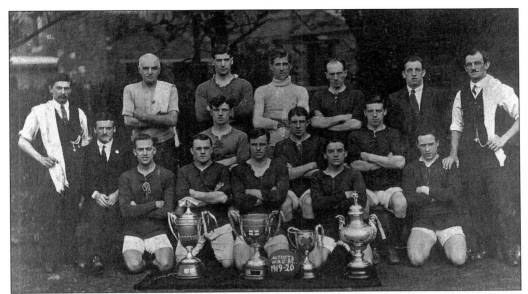

West Riding Colliery team, 1919. The team comprised: ? Beadle, ? Foote, A. Bastow, A. Kirk, E. Bagnall, J. Cooper, B. Kirk, H. Badley, H. Hall, I. Cooper, A. Hopson, T. Brown, A. Firth, W. Basins, S. Armstrong, A. Laycock, H. Ruston, G. Schofield. Two of the players were missing on the day of the photograph. All of the players lived within a mile of their ground.

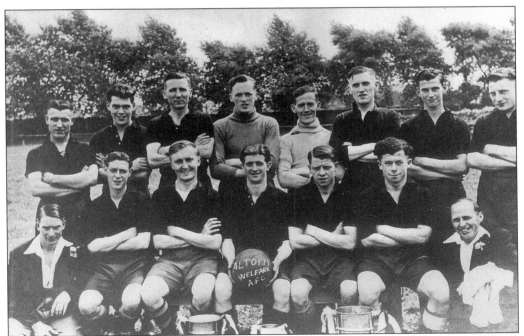

Altofts Dynamos. Back row, from left to right: W. Timmins, ? Dent, J. Beddows, ? Batham, W. Spink, ? Slatter, S. Kirby, L. Jones. Front row: H. Bradley (kneeling), J. Perry, ? Chivers, J. Cooper, H. Grimes, F. Senior, T. Doddy (kneeling).

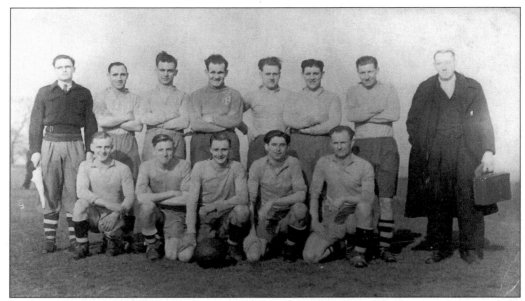

Snydale, 1945. Back row, from left to right: A. Chapman, -?-, ? Bucklow, A. Hanscome, ? Watson, R. Nichols, K. Smith, B. Banks. Front row: R. Sykes, H. Parkinson, ? Webb, R. Gibson, R. Newton.

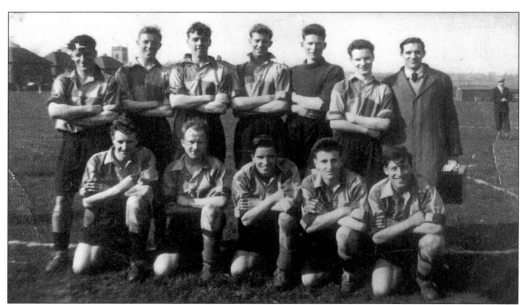

Snydale, 1953. Back row, from left to right: R. Stokes, W. Sadler, E. Slater, D. Wilby, D. Bettam, N. Hanning, -?- (trainer). Front row: C. Pugh, E. Jones, F. Dix, R. Johnson, D. Stokes.

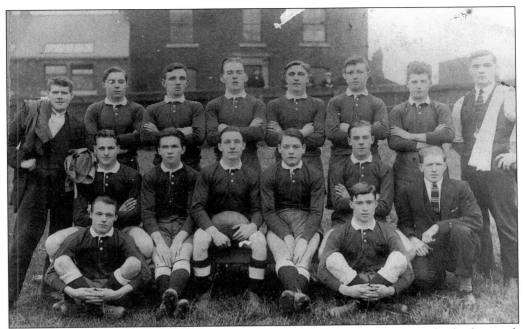

Normanton Intermediates Rugby Team in 1923. Garth House WMC is in the background. Back row, from left to right: ? Wilkinson (trainer), ? Wilkinson, J. Morley, J. Wilson, B. Sambrook, H. Butcher, ? Oaks, J. Bacon. Middle row: H. Downing, J. Walker, B. Ratcliffe (captain), J. Arthurs, B. Harper, ? Smith (bagman). Front: J. Trevis, H. Hall.

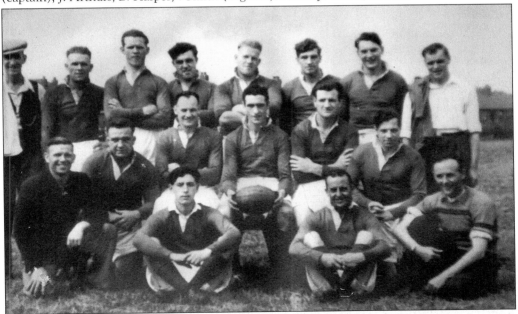

Normanton St Johns Rugby Team in 1949. Back row, from left to right: A. Dye (trainer), E. Golding, B. Hudson, A. Ackroyd, G. Atkinson, W. Watson, A. Oakley, A. Morton (ambulance man). Middle row: H. Golding, D. Tilford, L. Hossack, E. Barrett, J. Hughes, H. Brown, W. Dyson. Front: J. Wilson, S. Hudson.

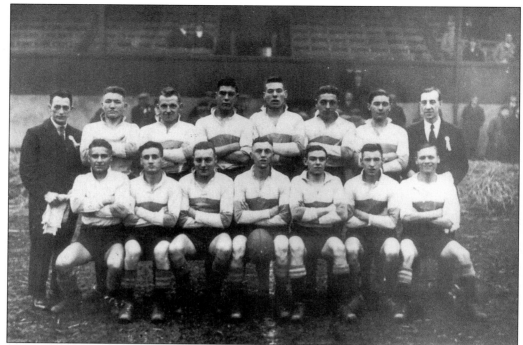

Garth House Intermediates, 1933. Back row, from left to right: N. Cox, ? Hargreaves, A. Fisher, W. Bryant, H. Smith, J. Dyson, A. Dye, -?-. Front row: W. Milner, ? Thomas, A. Hall, J. Price (captain), ? Brighton, A. Hodgkiss, A. Barraclough. All but one member of this team later joined professional clubs.

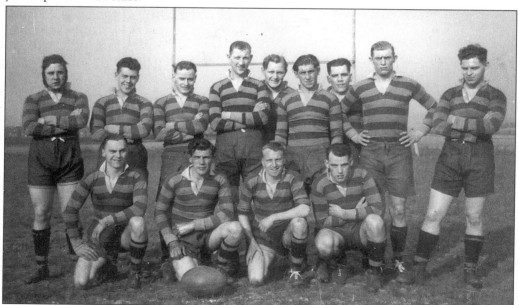

Silkstone Rovers, 1951. Back row, from left to right: T. Allen, R. Dent, G. Fradgley, R. Birchall, D. Pumford, K. Howell, C. Randall, L. Norton, L. Conlon. Front row: T. Perry, A. Davies (captain), K. Wood, K. Gill.

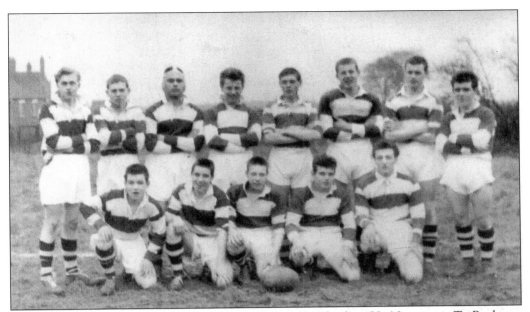

Leebrigg Bears, 1948. Among those pictured are: P. Thorley, H. Newsome, T. Rushton, D. Morse, M. Hartshorne, A. Dinsdale, T. Lethbridge, H. Bray, K. Brooks. The following people may be among the team members pictured: M. Bennett, A. Caswell, G. Thickbroom, M. Townend.

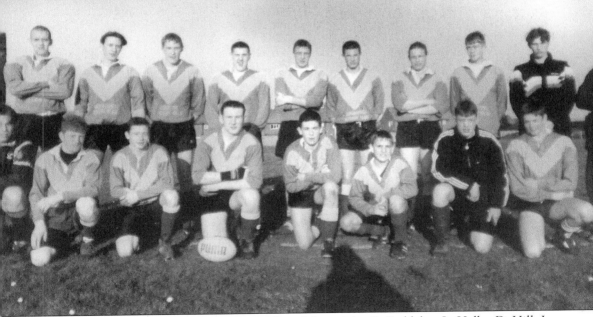

Normanton Under 18s in 1996. Back row, from left to right: S. Baddeley, L. Helks, D. Hill, I. Booth, M. Bamfield, S. Hayward, M. Gray, -?-, P. Handley, R. Hampshire (coach). Front row: S. Hague, P. Longley, A. Dyson, B. Cunningham, R. Tilford, J. Webb, P. Newsome, G. Barrett.

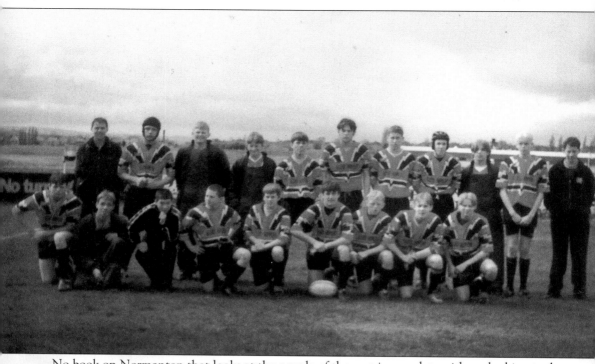

No book on Normanton that looks at the people of the past is complete without looking at the potential of the townspeople of the future. Normanton Talbot Under 14s are seen here in the 1997/98 season. Back row, from left to right: P. Waterton, P. Hale, J. Helme, N. Carmichael, J. Davies, P. Smith, D. Creswell, A. Wilson, M. Wray, J. Vaux, A. Layton. Front row: L. Ling, L. Kirk, A. Ashurst, P. Statham, D. Tate, A. Thaler, J. Westwood, C. Miles, S. Cardhall. Trophies won that season included the Wakefield Cup, Yorkshire Cup and English BARLA National Cup. They were also Champions of the Yorkshire League. All but two of the team are pupils at Normanton Freeston High School, the school team is the Yorkshire School Champion and the National Champion.